Antique Marks

Anna Selby
and The Diagram Group

HarperCollins*Publishers*
Westerhill Road, Bishopbriggs, Glasgow G64 2QT

www.collins.co.uk

A Diagram book first created by Diagram Visual
Information Limited of 195 Kentish Town Road,
London NW5 2JU

First published 1994
This edition published 2004

Reprint 10 9 8 7 6 5 4 3 2

© Diagram Visual Information Limited 1994, 2002, 2004

ISBN 0-00-719047-6

Printed in Italy by Amadeus S.r.l.

INTRODUCTION

Do you ever attend car boot sales or browse in antique shops in search of bargains? Have you ever wished you knew more about grandma's silver spoon or that old piece of china which has been around your home for so many years? Do you envy the experts' ability to identify and date such fascinating hand-me-downs? If the answer to any of these questions is yes, then *Collins Gem Antique Marks* is for you.

This handy reference work offers a wealth of detailed information which you can refer to at home, yet in a format which is small enough to slip into your bag or pocket. It can always be right at hand, ready to help you seize the chance of 'a good buy', or perhaps to protect you against an unwise purchase.

The book begins with a clear and thorough guide to the hallmarks stamped on British silver and gold ever since the Middle Ages, and those now found on platinum. There follows coverage of the quite different marks to be found on Old Sheffield Plate. A representative selection of Pewter makers' marks is provided next, as an introduction to these once so common household wares. Lastly, the book surveys the vast range of marks to be found on pottery and porcelain, both from Britain and the rest of Europe.

While the depth of knowledge of the true expert requires years of experience in handling and studying antiques, *Collins Gem Antique Marks* will provide you with the instant means to interpret the marks which are so often crucial in assessing antique objects.

CONTENTS

1. HALLMARKS ON SILVER, GOLD AND PLATINUM

Silver and gold have long been prized for their useful and attractive properties. Gold was one of the first metals to be discovered. Being soft and easy to work, colourful, bright and resistant to corrosion, it was ideal for jewellery and other decorative objects. Its scarcity ensured that its value remained high. Silver is harder and less scarce than gold, and thus more widely used in everyday life. Both silver and gold have been mined in Britain since Roman times, in modest quantities.

Platinum was unknown in Europe until 1600, only became available commercially in the 19th century, and has only been regulated in Britain since 1975. Used mainly for jewellery, it is more precious than gold.

The high value of these three metals makes it essential to have legally enforced standards of purity. The craft of the silversmith has been regulated by Parliamentary Acts and Royal Ordinances since the late 12th century.

Since 1 January 1975, a simplified scheme of hallmarks has been in use for British silver, gold and platinum, as directed by the Hallmarking Act of 1973.

PRE-1975 HALLMARKS AND WHAT THEY MEAN
Under the British regulations, any object made of silver or gold is stamped with various 'hallmarks' which enable us to tell when it was made, by whom, where it was manufactured or tested for purity, and, most important of all, how pure it is. The term 'hallmark' is

derived from Goldsmiths' Hall, the guild hall of the London Goldsmiths' Company, the body which oversaw the first assay marks in Britain. In 1300, the Sterling standard was established at 925 parts of silver per 1000 in an object, just as in English coinage. No object was allowed to leave the craftsman's hands until it had been assayed (tested) and marked with a punch depicting a leopard's head, a mark which is still used on London silver. Other assay offices were established in the English provinces, and in Scotland and Ireland, and all but the smallest had their own mark of origin.

From 1363, each craftsman was required to add his own 'maker's mark' and to register it.

From 1478, a 'date mark' was required to be struck, consisting of a letter of the alphabet which signified the year in which the piece had been assayed. This made it possible to trace the 'Keeper of the Touch' who had assayed a particular piece, in case of later disputes as to purity. It now allows us to determine an accurate date for any piece of British plate.

A 'duty mark' depicting the head of the current monarch is found on plate assayed between 1784 and 1890, as proof that a tax on silver goods had been paid by the maker. The duty mark should not be confused with later commemorative stamps which mark special occasions such as coronations and jubilees.

Marks of origin on British silver to 1974
The mark of origin, or assay office mark, identifies the town or city where the item in question was assayed,

and probably manufactured. Since 1300, London has used the leopard's head (**1**) (sometimes crowned, sometimes not). An exception is the period 1697–1720 when the 'lion's head erased' (**2**) was used, when the Britannia standard replaced the Sterling standard for English silver. At Edinburgh, the earliest Scottish assay office, the mark of origin has always been a three-towered castle (**3**). Dublin has used a harp crowned (**4**) since the mid-17th century. As further examples, Birmingham has long used an anchor (**5**), and Sheffield used a crown (**6**) for many years. More specific information on marks of origin will be found in the introductions to the tables of each city's hallmarks, later in the present chapter.

Sample marks of origin

1 2 3 4 5 6

Makers' marks

Since 1363, silversmiths have been required to stamp their work with a registered mark. Thus, one can identify the maker of a particular piece – at least if it was made after about 1666, when the earlier registers at Goldsmiths' Hall were burnt in the Great Fire of London. At first the custom was to use a rebus (for example, a picture of a fox for a silversmith whose surname was Fox) and initials combined in one mark. From 1697, makers were required by law to use the first two letters of their surnames (**a, b**), but from 1720 initials again became the norm (**c, d**), sometimes with a symbol added (**e, f**).

In Scotland before about 1700, makers commonly used a monogram (**g, h**), but this died out to be replaced by plain initials (**i**). Some used their full surname (**j**). In the case of factories or firms (**k**), the maker's mark is often called the 'sponsor's mark'.

Sample makers' marks

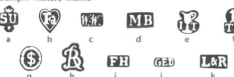

a b c d e f

g h i j k

a Thomas Sutton, London 1711
b John Farnell, London 1714
c William Woodward, London 1741
d Mathew Boulton, Birmingham 1790
e John Tuite, London 1739
f Thomas Morse, London 1720
g James Sympsone, Edinburgh 1687
h Robert Brook, Glasgow 1673
i Francis Howden, Edinburgh 1781
j Dougal Ged, Edinburgh 1734
k Lothian and Robertson, Edinburgh 1746

Date letters to 1974

Date letters were introduced in England from 1478, in Scotland (Edinburgh) from 1681, and in Ireland (Dublin) from 1638. The date letter system means that every item of hallmarked silver (and gold) carries a stamp indicating the year when it was assayed. The date stamp takes the form of a letter of the alphabet, changed to the next letter annually in a regular cycle,

rather like present-day car registrations. Different assay offices have used different cycles, omitting various letters of the alphabet to form sequences lasting from 19 to 26 years. 'I' was often used for 'J'. Each new cycle was given a new style of lettering and shape of shield, so as to distinguish one cycle from another.

The exact day of the year when the letter was changed varied at the different assay offices, and so is given in the introduction to each town later in this chapter.

Sample date letters

1 2 3 4 5 6

1 London 1561
2 London 1936
3 Birmingham 1891

4 Chester 1742
5 Dublin 1662
6 Edinburgh 1968

Standard marks to 1974

In England before 1544, the Sterling silver standard of 92.5 per cent purity (925 parts per 1000) was vouched for by the leopard's head mark of the London Assay Office (**a**). In 1544, Henry VIII debased the coinage to only one third silver, and so a specific 'standard mark' showing a lion passant (**b**) was introduced, to be marked on items which met the Sterling standard. In 1697, the Sterling standard was replaced by the Britannia standard of 95.84 per cent purity (958.4 parts per 1000), to stop the melting down of coins for plate. The Britannia figure (**b**) now replaced the lion passant

as the standard mark, and the lion's head erased (**d**) replaced the leopard's head as the mark of origin. From 1720, the Sterling standard and its lion passant mark were reintroduced, but silver of the higher standard continued to be marked with Britannia and the lion's head erased right up to 1974.

Edinburgh and Glasgow used different standards of fineness (as described on page 38) until 1836, when they adopted the Sterling and Britannia standards.

Sample standard marks

a b c d

Duty marks 1784–1890

Between 1784 and 1890 a duty (tax) was imposed on silver in Britain. To prove that the duty had been paid by the silversmith, an extra mark depicting the head of the current king or queen was struck on most items of silverware produced in England in those years. (In Dublin the duty was imposed only from 1807 and in Glasgow from 1819.) Silversmiths had many tricks to avoid paying duty, so the mark is not always present.

Duty marks

1 2 3 4

1 George III (1760–1820) **3** William IV (1830–1837)
2 George IV (1820–1830) **4** Victoria (1837–1901)

Commemorative marks

Special marks have been added in certain calendar years to mark notable occasions. A mark with the heads of both King George V and Queen Mary (**1**) was used to mark their Silver Jubilee in 1935. The coronation of Elizabeth II in 1953 was commemorated with a mark of the Queen's head (**2**). A similar mark (**3**) was used again to mark her Silver Jubilee in 1977, and a new mark (**4**) issued to commemorate her Golden Jubilee in 2002. Special commemorative marks have also been used by the Dublin, Birmingham and Sheffield assay offices. Because of the exact time of year when the date letter was changed at a particular assay office, such marks may appear not only with the date letter of the year commemorated, but also with that of the year before or the one after.

1

2

3

4

Marks on foreign silver to 1974

From 1867, a letter F (**a**) was stamped on foreign plate imported into Britain. From 1904, the decimal value of the Sterling (**b**) and Britannia (**c**) standards was marked on imported silver which met those standards, and each assay office had a special mark of origin, as used on imported gold (*see page 136*), but in an oval shield.

a

b

c

THE HALLMARKING ACT OF 1973

In 1973 a new Act of Parliament was passed for regulating and simplifying the law regarding hallmarks on silver, gold and platinum in Britain, and it came into force on 1 January 1975. The Act governs hallmarks at the four remaining assay offices, in London, Edinburgh, Birmingham and Sheffield (but not Dublin, which since 1921 has been the captial of the independent Irish Republic). All items weighing more than 7.8 grams must be hallmarked before they can be described as silver (for gold it is any item above 1 gram, and for platinum above 0.5 gram). There are four hallmarks in total: the registered maker's or sponsor's mark, the standard mark, the mark of origin (assay office mark), and the date letter.

Sample modern silver hallmarks

1

2

3

4

1 Maker's mark
2 Standard mark

3 Mark of origin
4 Date letter

Standard marks from 1975

On Sterling silver, the London, Birmingham and Sheffield assay offices still use the traditional lion passant (**a**), while Edinburgh uses the lion rampant (**b**). At all four offices, the Britannia mark (**c**) is used (without the old accompanying lion's head erased) on silver which meets the Britannia standard.

 a

 b

 c

Marks of origin from 1975

Only four assay offices remained open in Britain by 1975. London still uses a leopard's head (**1**). Birmingham still uses its anchor (**2**) and Edinburgh its three-towered castle (**3**). However, Sheffield has adopted a York rose (**4**) to replace the crown which it had used for over 200 years, because the crown risked being confused with a similar mark on gold. Dublin is not affected by the Act, and still uses its harp crowned.

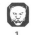

1 2 3 4

Date letters from 1975

The date letter now coincides exactly with the calendar year, it being changed on 1 January every year, and the same style is used by all four British assay offices.

Imported foreign silver from 1975

The marking of imported foreign silver has been simplified and standardised under the 1973 Act. The standard mark consists of the millesimal value in an oval shield (*see below*). The marks of origin used by the four assay offices are similar to those on foreign gold and platinum, but in an oval shield (*see below*).

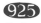 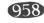

Sterling Britannia

London Birmingham Sheffield Edinburgh

Convention marks

New hallmarking regulations came into effect in the United Kingdom on 1 January 1999. These implemented the judgement of The European Court of Justice that no member state of the European Union may require new hallmarks to be attached to articles imported from other member states if those articles have already been hallmarked in accordance with the laws of that member state. All articles made from precious metals in the United Kingdom now have a standard metal fineness (purity) mark known as a common control mark (*see below*). The number gives the minimum quantity of the precious metal in the article in millesimals (parts per thousand). For example, the number 925 guarantees that the article is at least 92.5% pure. The shape of the control mark indicates the type of precious metal.

Common control marks

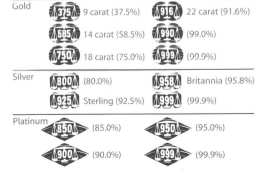

Gold			
375	9 carat (37.5%)	916	22 carat (91.6%)
585	14 carat (58.5%)	990	(99.0%)
750	18 carat (75.0%)	999	(99.9%)

Silver			
800	(80.0%)	958	Britannia (95.8%)
925	Sterling (92.5%)	999	(99.9%)

Platinum			
850	(85.0%)	950	(95.0%)
900	(90.0%)	999	(99.9%)

The British Hallmarking Council

A body called the British Hallmarking Council was established under the 1973 Act, and became operative in 1975. The council coordinates the activities of the four assay offices, without hindering their independence. Its main responsibility is to ensure that adequate assaying facilities are available in the UK, and to see that laws relating to assaying are adhered to.

READING THE HALLMARK CHARTS IN THIS BOOK

Layout of the hallmark charts

The charts on the pages which follow show the hallmarks associated with each of the towns or cities which have had important assay offices, presented in the order in which the assay offices were established. Within each section, all the variations in the design of that city's mark of origin (**b**) and the standard marks (**c** and sometimes **d**) are illustrated, and these are followed by any duty marks or commemorative marks (**e**) and by the date letters (**f**). Unusual marks are fully explained in special feature panels (**a**). Makers' marks are shown separately in lists at the end of each city's section.

For gold, the marks of origin are the same as for silver, except in the cases of Birmingham and Dublin (*see pages 135–6*). Date letters are the same for gold and platinum as they are for silver.

Note that the hallmark charts apply primarily to silver (as they show the standard marks for silver), but that the same date letters apply equally to British gold.

Here is a sample of a set of marks which you may be looking for (although they may not appear in this order):

In the charts they would be shown as follows:

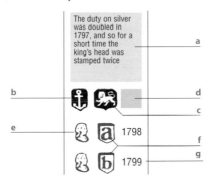

a Text box for unusual markings

b Mark of origin

c Standard mark

d Possible second standard mark

e Duty or commemorative mark

f Date letter mark

g Text showing year

HOW TO READ HALLMARKS

- When looking at hallmarks, begin by studying the mark of origin to find out where the piece was assayed. (If no assay office's mark is present, the piece probably comes from London.)

- Turn to the relevant city's section in the tables of hallmarks. Now look at the date letter. Examine the letter to see whether it is a capital or a small letter; check what kind of script it is in; and note the shape of the shield containing it.

- Compare these features with the letters in the correct city's tables. Only when you find the example in the table which exactly matches your hallmark can you be confident about its date.

- Once the place and date of origin are established, it is relatively simple to look up the maker's or sponsor's mark and find out the name of the craftsman or company.

- Other marks will give extra information, such as whether the piece is Sterling or Britannia silver, whether duty was paid on it, and whether it was made in a coronation or jubilee year.

LONDON

The Goldsmiths' Company in London was the first in England authorised to assay and mark gold and silver, after the granting of a Royal Charter in 1327. London has been by far the most important British assay office, both in terms of the high quality of workmanship it maintained, and of the amount and variety of silverware passing through it.

London's mark of origin is a leopard's head, crowned from 1478 to 1821 and thereafter uncrowned. The shape of the head and crown have varied over the years, as has the shield surrounding them. From 1697 until 1720 (while the Britannia standard was in force) the leopard's head was replaced by the lion's head erased, and the Britannia mark. From 1784 until 1890 the sovereign's head duty mark was in use.

From 1478 to 1974 London traditionally used a 20-letter sequence (A to U omitting J), with the letter being changed in May each year. Since 1975 all British date letter sequences have been standardised, and are changed on 1 January. In the same year platinum was first assayed and marked here.

The London Assay Office is still in operation.

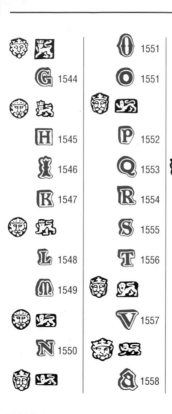

	G 1544
	H 1545
	I 1546
	K 1547
	L 1548
	M 1549
	N 1550

O	1551
O	1551
P	1552
Q	1553
R	1554
S	1555
T	1556
V	1557
A	1558

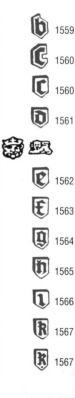

b	1559
C	1560
C	1560
D	1561
e	1562
F	1563
g	1564
h	1565
I	1566
k	1567
k	1567

1568	1578	1590
1569	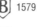 1579	1591
1570	1580	
1571	1581	1592
1572	1582	1593
1573	1583	1594
1574	1584	1595
1575	1585	1596
1575	1586	1597
1576	1587	
1577	1588	1598
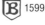	1589	1599

C 1600	P 1612	f 1623
D 1601	Q 1613	g 1624
E 1602	R 1614	h 1625
F 1603	S 1615	i 1626
G 1604	T 1616	k 1627
h 1605	V 1617	l 1628
I 1606		m 1629
K 1607	a 1618	n 1630
L 1608	b 1619	o 1631
M 1609	c 1620	p 1632
N 1610	d 1621	q 1633
O 1611	e 1622	r 1634

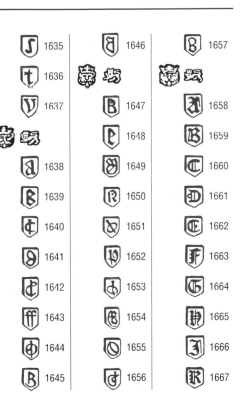

1635	1646	1657
1636	1647	1658
1637	1648	1659
1638	1649	1660
1639	1650	1661
1640	1651	1662
1641	1652	1663
1642	1653	1664
1643	1654	1665
1644	1655	1666
1645	1656	1667

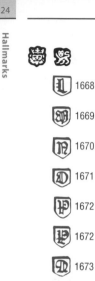

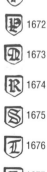

1668

1669

1670

1671

1672

1672

1673

1674

1675

1676

1677

1678

1679

1680

1681

1682

1683

1684

1685

1686

1687

 1688

 1689

 1690

 1691

 1692

 1693

 1694

 1695

 1696
1697

 1697

1697

 1698

 1699

 1700

 1701

 1702

 1702

 1703

 1704

 1705

 1706

 1707

 1708

 1709

 1710

 1711

 1712

 1713

 1714

 1715

From 1716 to 1728, the shield shape for the date letter occasionally varied

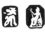

 1716

 1717

 1/18

 1719

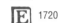 1720

 1721

 1722

 1723

ⓘ 1724	Ⓣ 1734	ⓗ 1743
Ⓚ 1725	Ⓥ 1735	ⓘ 1744
🛡️🦁	🛡️🦁	Ⓚ 1745
Ⓛ 1726	ⓐ 1736	ⓛ 1746
Ⓜ 1727	ⓑ 1737	ⓜ 1747
Ⓝ 1728	ⓒ 1738	ⓝ 1748
🛡️🦁	ⓓ 1739	ⓞ 1749
Ⓞ 1729	🛡️🦁	ⓟ 1750
Ⓟ 1730	ⓓ 1739	
Ⓠ 1731	ⓔ 1740	ⓠ 1751
Ⓡ 1732	ⓕ 1741	ⓡ 1752
Ⓢ 1733	ⓖ 1742	ⓡ 1753

 1754

 1755

 1756

 1757

 1758

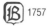 1759

 1760

 1761

 1762

 1763

 1764

 1765

 1766

 1767

 1768

 1769

 1770

 1771

 1772

 1773

 1774

 1774

1775

Two shield shapes for standard mark found, 1770–1795

From 1776 to 1875, a shield without a point was used for some small articles

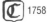 1776

 1777

 1778

 1779

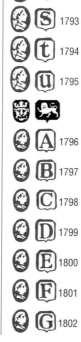
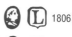
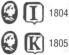
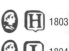

e 1780	r 1792	H 1803
f 1781	s 1793	I 1804
g 1782	t 1794	K 1805
h 1783	u 1795	L 1806
i 1784		M 1807
k 1785	A 1796	N 1808
l 1786	B 1797	O 1809
m 1787	C 1798	P 1810
n 1788	D 1799	Q 1811
o 1789	E 1800	R 1812
p 1790	F 1801	S 1813
q 1791	G 1802	T 1814

 1815

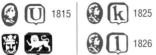

 1816

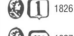 1817

 1818

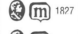 1819

 1820

 1821

 1822

 1823

 1824

 1825

 1826

 1827

 1828

 1829

 1830

 1831

 1832

 1833

 1834

 1835

 1836

 1837

 1838

 1839

 1840

 1841

 1842

 1843

 1844

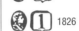 1845

 1846

 1847

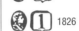

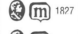

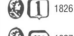

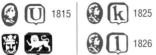

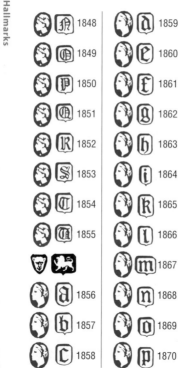

1848	1859	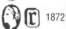 1871
1849	1860	1872
1850	1861	1873
1851	1862	1874
1852	1863	1875
1853	1864	
1854	1865	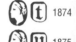 1876
1855	1866	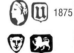 1876
	1867	1877
1856	1868	1877
1857	1869	1878
1858	1870	1879
		1880

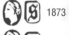

 1881

 1882

 1883

 1884

 1885

 1886

 1887

 1888

 1889

1890

The queen's head duty mark was not used after 1890

 1891

 1892

 1893

 1894

 1895

 1896

 1902

 1903

 1904

 1905

 1906

 1907

 1908

 1909

 1910

 1911

1912

1913

Column 1	Column 2	Column 3
t 1914	k 1925	[lion marks]
u 1915	l 1926	A 1936
[lion marks]	m 1927	B 1937
a 1916	n 1928	C 1938
b 1917	o 1929	D 1939
c 1918	p 1930	E 1940
d 1919	q 1931	F 1941
e 1920	r 1932	G 1942
f 1921	s 1933	H 1943
g 1922	[lion marks]	I 1944
h 1923	t 1934	K 1945
i 1924	u 1935	L 1946

M 1947	**a** 1956	**n** 1968
N 1948	**b** 1957	**o** 1969
O 1949	**c** 1958	**p** 1970
P 1950	**d** 1959	**q** 1971
Q 1951	**e** 1960	**r** 1972
	f 1961	**s** 1973
R 1952	**g** 1962	**t** 1974
S 1953	**h** 1963	New letter sequence commenced on 1 January 1975, in accordance with the Hallmarking Act passed in 1973
	i 1964	
T 1954	**k** 1965	
U 1955	**l** 1966	
	m 1967	**A** 1975

 B 1976

C 1977

D 1978

E 1979

F 1980

G 1981

H 1982

I 1983

K 1984

L 1985

M 1986

N 1987

O 1988

P 1989

Q 1990

R 1991

S 1992

T 1993

U 1994

V 1995

W 1996

X 1997

Y 1998

Z 1999

a 2000

b 2001

c 2002

d 2003

e 2004

f 2005

g 2006

h 2007

i 2008

j 2009

LONDON MAKERS' MARKS

ABS	Adey B Savory
AF SG	Andrew Fogelberg & Stephen Gilbert
AS	Thomas Ash
BC	Benjamin Cooper
BS	Benjamin Smith
BS BS	Benjamin Smith & Son
Bu/BU	Thomas Burridge
CF	Charles Fox or Crispin Fuller
CK	Charles F Kandler (star below)
CO	Augustin Courtauld (fleur-de-lys above)
CR	Charles Rawlins
CR DR	Christian & David Reid
CR GS	Charles Reilly & George Storer
CR WS	Charles Rawlins & William Summers
DH	David Hennell
DM	Dorothy Mills
DPW	Dobson, Prior & Williams
DS BS	Digby Scott & Benjamin Smith
DS RS	Daniel Smith & Robert Sharp

EC	Ebenezer Coker
EF	Edward Feline
ET	Elizabeth Tuite
EW	Edward Wigan
EY	Edward Yorke
FC	Francis Crump
FO	Thomas Folkingham
GA	George Adams
GS	George Smith
GS WF	George Smith & William Fearn
GW	George Wintle
HA	Pierre Harache (crown above)
HB	Hester Bateman
HC	Henry Chawner
HC IE	Henry Chawner & John Emes
HN	Hannah Northcote
IB	James Bult
IC	John Carter
IG	John Gould
IH	John Hyatt
IL HL	John & Henry Lias
IL HL CL	John, Henry & Charles Lias
IP	John Pollock

LONDON MAKERS' MARKS (continued)

IS	John Swift or John Scholfield
IW IT	John Walcelon & John Taylor
JA	Joseph Angell
JA JA	J & J Aldous
JC	John Cafe
JE	John Emes
JL	John Lias
LA	Paul de Lamerie (crown and star above)
LO	Nathaniel Lock
LP	Lewis Pantin
MC	Mary Chawner
ME	Louis Mettayer
MP	Mary Pantin
MS	Mary Sumner
MS ES	Mary & Elizabeth Sumner
Ne	Anthony Nelme
NS	Nicholas Sprimont
PB AB	Peter & Anne Bateman
PB AB WB	Peter, Anne & William Bateman
PB IB	Peter & Jonathan Bateman

PL	Pierre Platel
PL	Paul de Lamerie (crown and star above, fleur-de-lys below)
PS	Paul Storr
Py	Benjamin Pyne (rose and crown above)
RC	Richard Crossley
RC GS	Richard Crossley & George Smith
R DH H	Robert & David Hennell
RE EB	Rebecca Emes & Edward Barnard
RE WE	Rebecca & William Emes
RG	Robert Garrard
RH	Robert Hennell
RH DH	Robert & David Hennell
RH DH SH	Robert, David & Samuel Hennell
RH SH	Robert & Samuel Hennell
RM RC	Robert Makepeace & Richard Carter

RM	Robert & Thomas	**TR**	Thomas Robins
TM	Makepeace	**T**	Thomas &
Ro	Philip Rolles	**WC**	William Chawner
RR	Richard Rugg or	**C**	
	Robert Rutland	**WB**	William Burwash
RS	Robert Swanson	**WC**	William Cafe
SA	Stephen Adams	**WE**	William Eaton or
Sc	William Scarlett		William Eley
SC	S & J Crespell	**WE**	William, Charles
IC		**CE**	& Henry Eley
SG	Samuel Godbehere	**HE**	
SG	Samuel Godbehere	**WE**	William Eley &
EW	& Edward Wigan	**GP**	George Pierrepont
SL	Gabriel Sleath	**WE**	William Eley &
SM	Samuel Meriton	**WF**	William Fearn
Sp	Thomas Spackman	**WF**	William Fearn
S	Stephen Adams &	**WF**	William Frisbee &
WI	William Jury	**PS**	Paul Storr
A		**WG**	William Grundy
TH	Thomas Heming	**WI**	David Willaume
TH	Thomas Hannam	**WP**	William Peaston or
IC	& John Crouch		William Plummer
T & W	Turner & Williams	**WRS**	W R Smiley
TN	Thomas Northcote	**WS**	William Sumner or
TO	Thomas Oliphant		William Smiley
TP	Thomas Phipps &	**WT**	William Tweedie
ER	Edward Robinson	**W**	William Shaw &
TP	Thomas Phipps,	**WP**	William Priest
ER	Edward Robinson	**S**	
JP	& James Phipps		
TP	Thomas & James		
IP	Phipps		

EDINBURGH

Silver was assayed in Edinburgh from the middle of the 15th century, although the first known specimens date from a century later than that. There was an Incorporation of Goldsmiths here from at least the 1490s. Over the years Edinburgh has been known particularly for ecclesiastical and domestic silverware.

The Edinburgh mark of origin is a three-towered castle. Before 1681 the standard mark took the form of the Deacon's mark, a monogram of the initials of the current holder of that office. From 1681 the Deacon's mark was replaced by the Assay Master's mark, again consisting of the office-holder's initials. This was replaced in 1759 by a thistle, which changed in 1975 to a lion rampant. From 1784 to 1890 the sovereign's head duty mark was in use.

From 1457 to 1836 Edinburgh used a standard of 916.6 parts of silver per thousand, except 1489–1555, when the Standard of Bruges was used (varying from 917 to 946 parts per thousand according to the size of the object). Only from 1836 was the Sterling standard adopted at Edinburgh.

Date letters came into use in 1681. Edinburgh generally used a 25-letter sequence, omitting J (although it was included in 1789 and 1815). The letter was changed in October. From 1 January 1975 the standard British date letter sequence has been used.

The Edinburgh Assay Office is still in operation. Platinum was first marked here in 1982.

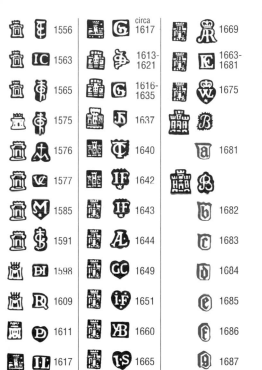

1556	circa 1617	1669
1563	1613–1621	1663–1681
1565	1616–1635	1675
1575	1637	
1576	1640	1681
1577	1642	
1585	1643	1682
1591	1644	1683
1598	1649	1684
1609	1651	1685
1611	1660	1686
1617	1665	1687

 1688

 1689

1690

1691

 1692

1693

 1694

1695

 1696

 1697

 1698

1699

1700

1701

 1702

1703

 1704

 1705

 1706

1707

1708

1709

1710

1711

 1712

 1713

 1714

1715

 1716

 1717

 1718

 1719

 1719

 1720

 1721

1722

1723

 1724

1725

 1725

1726

1727

1728

1729

 1730

1731

1732

1733

 1734

1735

 1736

1737

 1738

 1739

 1740

1741

 1742

1743

 1744

 1745

 1746

 HG

 1747

1748

1749

1750

1751

1752

1753

1754

HG

 1755

1756

1757

1758

 1759

1760

1761

1762

 1763

1763

 1764

 1765

 1766

1767

1768

1769

1770

1771

These alternative town marks are found circa 1771

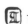 1772

1773

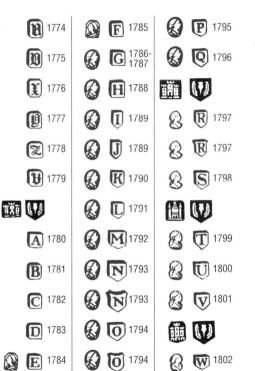

1774		1785		1795	
1775		1786-1787		1796	
1776		1788			
1777		1789		1797	
1778		1789		1797	
1779		1790		1798	
		1791			
1780		1792		1799	
1781		1793		1800	
1782		1793		1801	
1783		1794			
1784		1794		1802	

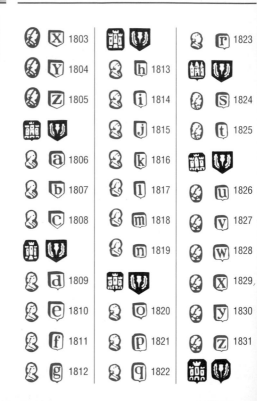

	X	1803		h	1813	r	1823
	Y	1804		h	1813		
	Z	1805		i	1814	S	1824
				j	1815	t	1825
	a	1806		k	1816		
	b	1807		l	1817	u	1826
	c	1808		m	1818	v	1827
				n	1819	w	1828
	d	1809				x	1829
	e	1810		O	1820	y	1830
	f	1811		p	1821	z	1831
	g	1812		q	1822		

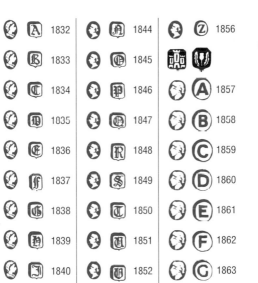

🙂	Ⓐ	1832	🙂	🄰	1844	🙂	Ⓩ	1856
🙂	Ⓑ	1833	🙂	🄼	1845	🏰	🛡	
🙂	Ⓒ	1834	🙂	🄿	1846	🙂	Ⓐ	1857
🙂	Ⓓ	1035	🙂	🅀	1847	🙂	Ⓑ	1858
🙂	Ⓔ	1836	🙂	🅁	1848	🙂	Ⓒ	1859
🙂	ff	1837	🙂	🅂	1849	🙂	Ⓓ	1860
🙂	Ⓖ	1838	🙂	🅃	1850	🙂	Ⓔ	1861
🙂	Ⓗ	1839	🙂	🅄	1851	🙂	Ⓕ	1862
🙂	Ⓙ	1840	🙂	🅅	1852	🙂	Ⓖ	1863
🙂	Ⓚ	1841	🙂	🅆	1853	🙂	Ⓗ	1864
🙂	Ⓛ	1842	🙂	🅇	1854	🙂	Ⓘ	1865
🙂	Ⓜ	1843	🙂	🅈	1855	🙂	Ⓚ	1866

L 1867	X 1879	i 1890
M 1868	Y 1880	k 1891
N 1869	Z 1881	l 1892
O 1870	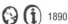 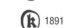	m 1893
P 1871	a 1882	n 1894
Q 1872	b 1883	o 1895
R 1873	c 1884	p 1896
S 1874	d 1885	q 1897
T 1875	e 1886	r 1898
U 1876	f 1887	s 1899
V 1877	g 1888	t 1900
W 1878	h 1889	v 1901

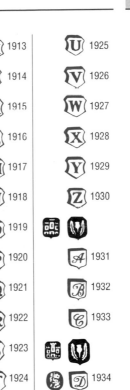

(w) 1902	(H) 1913	(U) 1925
(r) 1903	(I) 1914	(V) 1926
(u) 1904	(K) 1915	(W) 1927
(3) 1905	(L) 1916	(X) 1928
(A) 1906	(M) 1917	(Y) 1929
(B) 1907	(N) 1918	(Z) 1930
(C) 1908	(O) 1919	(A) 1931
(D) 1909	(P) 1920	(B) 1932
(E) 1910	(Q) 1921	(C) 1933
(F) 1911	(R) 1922	(D) 1934
(G) 1912	(S) 1923	
	(T) 1924	

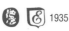 1935

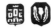 1936 (G) 1937 (H) 1938

 1939

(K) 1940

(L) 1941

(M) 1942

(N) 1943

(O) 1944

(P) 1945

(Q) 1946

(R) 1947

(S) 1948

(T) 1949

(U) 1950

(V) 1951

 1952

 1953

 1954

(Z) 1955

(A) 1956

(B) 1957

(C) 1958

(D) 1959

(E) 1960

(F) 1961

(G) 1962

(H) 1963

(I) 1964

(K) 1965

 1966

 1977

 1988

 1967

 1989

 1968

 1978

 1990

1969

 1979

1991

1970

 1980

1992

1971

 1981

 1993

1972

 1982

 1994

 1973–1974

 1983

1995

 1984

 1996

1975

 1985

1997

1976

 1986

1998

 1987

 1999

 2000 | 2001 | 2002

EDINBURGH MAKERS' MARKS

AE	Alexander Edmonstone	**JMc**	John McKay
AG	Alexander Gairdner	**JN**	James Nasmyth
AH	Alexander Henderson	**J&WM**	James & William Marshall
AK	Alexander Kincaid	**LO**	Lawrence Oliphant
AS	Alexander Spencer	**LU**	Leonard Urquhart
AZ	Alexander Zeigler	**MC**	Matthew Craw
CD	Charles Dixon	**M&C**	McKay & Chisholm
E&Co	Elder & Co	**M&F**	McKay & Fenwick
EL	Edward Lothian	**M&S**	Marshall & Sons
EO	Edward Oliphant	**MY**	Mungo Yorstoun
GC	George Christie	**PM**	Peter Mathie
GF	George Fenwick	**PR**	Patrick Robertson
G&K	Gilsland & Ker	**PS**	Peter Sutherland
GMH	George McHattie	**RB**	Robert Bowman
GS	George Scott	**RC**	Robert Clark
HB	Henry Beathume	**RG**	Robert Gordon
HG	Hugh Gordon	**RI**	Robert Inglis
ID	James Dempster	**RK**	Robert Ker
IG	John Gilsland	**WG**	William Ged
IK	James Ker	**W&PC**	William & Peter Cunningham
IR	James Rollo	**WR**	William Robertson
IW	John Walsh	**WS**	Walter Scott
IZ	John Zeigler	**WT**	William & Jonathan Taylor
JD	James Douglas	**IT**	
JM	Jonathan Millidge		

YORK

The assaying of silver in York dates from the mid-16th century. York silver generally followed Scandinavian styles, and is known for pieces of basic design intended for everyday use. From 1717 to 1776 the York Assay Office was closed, and silver made there was assayed at Newcastle.

The York mark of origin was initially a halved leopard's head conjoined with a halved fleur-de-lys in a round shield. In the late 17th century the halved leopard's head was replaced by a halved seeded rose. This mark underwent numerous changes before, in 1701, it was replaced by a new mark depicting five lions passant on a cross, based on the York City coat of arms. From 1700 to 1850 a leopard's head accompanied the lion passant standard mark on York Sterling silver, while the Britannia mark and lion's head erased were used on York Britannia silver. From 1784 to 1856 (when the York Assay Office closed down), the sovereign's head duty mark was in use.

From at least 1607, York generally used a 24-letter date sequence omitting J and U, then from 1787 a 25-letter sequence omitting just J.

 circa 1568

 circa 1577

 circa 1583

 circa 1594

Numerous versions of the town mark (*see above*) were used at the York Assay Office from c1560 to c1606

 F 1564

 G 1565

 H 1566

K 1568

L 1569

 M 1570

 O 1572

 P 1573

 Q 1574

R 1575

S 1576

T 1577

Z 1582

 a 1583

 b 1584

 e 1587

h 1590

k 1592

 l 1593

 m 1594

n 1595

 o 1596

 p 1597

 q 1598

 r 1599

 t 1601

 x 1604

 circa 1608

 circa 1624

From 1607 to 1630, two versions of the town mark (*see previous page*) were used at the York Assay Office

 1607

 1608

 1609

 1610

 1611

 1612

1613

1614

1615

 1616

 1617

 1618

1619

1620

1621

 1622

1623

1624

 1625

1626

1627

1628

1629

1630

From 1631 to 1656, two versions of the town mark (*see below*) were used at York Assay Office

 1631

 1632

1633

 1634

 1635

 1628

 1629

 1630

 1616

 1617

 1618

f 1636	w 1653	H 1664
g 1637	x 1654	J 1665
h 1638	y 1655	K 1666
i 1639	z 1656	L 1667
k 1641	(mark)	M 1668
l 1642	A 1657	N 1669
m 1643	B 1658	Ø 1670
o 1645	C 1659	P 1671
J 1649	D 1660	Q 1672
t 1650	E 1661	R 1673
u 1651	F 1662	S 1674
v 1652	G 1663	T 1675

York 1636–17C8



 1676

1677

1678

1679

1680

1681

From 1682 to 1699, two versions of the town mark (*see below*) were used at York Assay Office

circa 1680

circa 1696

1682

1683



1684

1685

1686

1687

1688

1689

1690

1691

1692

1693

1694

1695



 1696

1697

1698

1699

 1700

1701

1702

1703

1705

1706

1708

Column 1

 1711

1713

No York plate has been found from the years 1714 to 1777 inclusive

 C 1778

 D 1779

 E 1780

 F 1781

 G 1782

 H 1783

 J 1784

Column 2

 K 1785

 L 1786

 A 1787

 B 1788

 C 1789

 C 1789

 d 1790

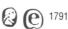 e 1791

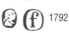 f 1792

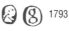 g 1793

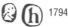 h 1794

Column 3

 i 1795

 k 1796

L 1797

M 1798

N 1799

O 1800

 P 1801

 Q 1802

In 1803, and again in 1806, the lion passant faced right

 R 1803

 S 1804

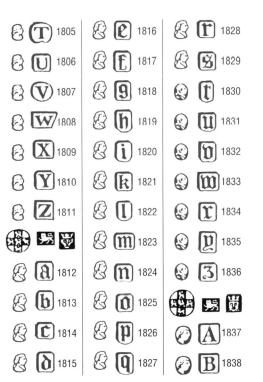

T 1805	e 1816	r 1828
U 1806	f 1817	s 1829
V 1807	g 1818	t 1830
W 1808	h 1819	u 1831
X 1809	i 1820	v 1832
Y 1810	k 1821	w 1833
Z 1811	l 1822	x 1834
	m 1823	y 1835
a 1812	n 1824	z 1836
b 1813	o 1825	A 1837
c 1814	p 1826	B 1838
d 1815	q 1827	

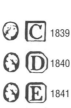 1839

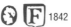 1840

 1851

 1841

 1852

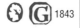 1842

1853

1843

1854

1844

1855

1845

1856

1846

York Assay Office
closed in 1856

1847

 1848

 1849

 1850

YORK MAKERS' MARKS

BC & N	James Barber, George Cattle, William North		**JB GC WN**	James Barber, George Cattle, William North
B & N	James Barber, William North		**JB WN**	James Barber, William North
Bu	William Busfield		**JB WW**	James Barber, William Whitwell
HP & C	John Hampston, John Prince, Robert Cattle		**La**	John Langwith
			Ma	Thomas Mangy
IH IP	John Hampston & John Prince		**P & Co**	John Prince, Robert Cattle
JB & Co	James Barber & Co		**RC JB**	Robert Cattle, James Barber

NORWICH

The earliest known Norwich silver marks date from the mid-16th century. The city is known principally for ecclesiastical and corporation plate.

The town mark was a lion passant surmounted by a castle. From the early 17th century another town mark was also in use, namely a seeded rose crowned, and variations of both marks appeared until 1701. After 1701 virtually no silver was assayed in Norwich.

Norwich used a 21-letter date sequence (A to V omitting J). The letter was changed each September.

There are no recorded makers' marks from Norwich.

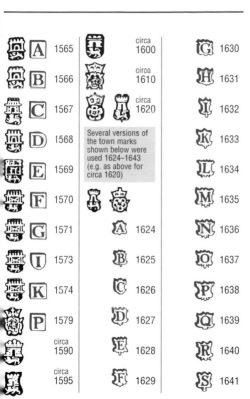

A	1565	circa 1600
B	1566	circa 1610
C	1567	circa 1620
D	1568	Several versions of the town marks shown below were used 1624–1643 (e.g. as above for circa 1620)
E	1569	
F	1570	A 1624
G	1571	B 1625
I	1573	C 1626
K	1574	D 1627
P	1579	E 1628
	circa 1590	F 1629
	circa 1595	

G	1630
H	1631
I	1632
K	1633
L	1634
M	1635
N	1636
O	1637
P	1638
Q	1639
R	1640
S	1641

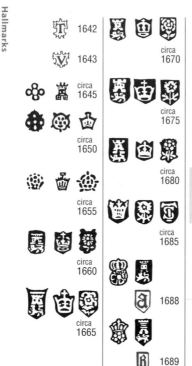

 1642

 1643

circa 1645

circa 1650

circa 1655

circa 1660

circa 1665

circa 1670

circa 1675

circa 1680

circa 1685

1688

1689

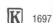 1691

1696

1697

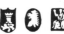 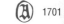 1701

Little, if any, silver was assayed at Norwich after 1701

EXETER

The earliest assay marks date from the mid-16th century. Exeter is known for a good standard of ecclesiastical and domestic silver, but small items were rarely made.

The mark of origin was a round shield containing the letter X surmounted by a crown. After 1701 this was replaced with a three-towered castle. From 1701 to 1720 the Britannia mark and the lion's head erased were in use together as standard marks. After 1721 these were replaced with the leopard's head (omitted from 1777) and the lion passant in square shields. The sovereign's head duty mark was in use from 1784 to 1882.

The date letters began in 1701. Exeter initially used a 24-letter sequence (omitting J and U) then from 1797 a 20-letter sequence (A to U omitting J). The date letter was changed in August.

Little silver was assayed in Exeter by the end of the 18th century, and the office closed in 1883.

X IONS circa 1570	X ✿ circa 1698	L 1711
I n circa 1571	🏛 🦁 🐇	M 1712
X ❀ circa 1575	A 1701	N 1713
X circa 1580	B 1702	O 1714
X circa 1585	C 1703	P 1715
Various town marks were used at Exeter in about 1630	D 1704	Q 1716
	E 1705	R 1717
X circa 1635-1675	F 1706	S 1718
X circa 1635-1675	G 1707	T 1719
X circa 1680	H 1708	V 1720
X circa 1690	I 1709	🏛 🦁
X 🦁 circa 1690	K 1710	W 1721

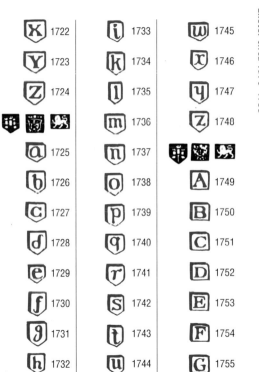

X 1722	i 1733	w 1745
Y 1723	k 1734	x 1746
Z 1724	l 1735	y 1747
🛡🛡🦁	m 1736	z 1740
a 1725	n 1737	🛡🛡🦁
b 1726	o 1738	A 1749
c 1727	p 1739	B 1750
d 1728	q 1740	C 1751
e 1729	r 1741	D 1752
f 1730	s 1742	E 1753
g 1731	t 1743	F 1754
h 1732	u 1744	G 1755

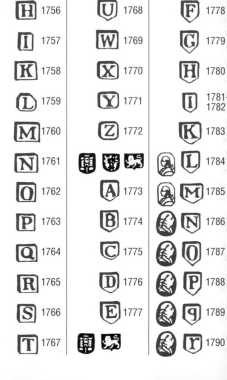

H 1756
I 1757
K 1758
L 1759
M 1760
N 1761
O 1762
P 1763
Q 1764
R 1765
S 1766
T 1767

U 1768
W 1769
X 1770
Y 1771
Z 1772

A 1773
B 1774
C 1775
D 1776
E 1777

F 1778
G 1779
H 1780
I 1781-1782
K 1783
L 1784
M 1785
N 1786
O 1787
P 1788
q 1789
r 1790

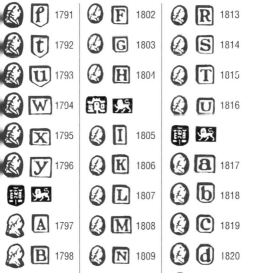

![] [f] 1791	![] [F] 1802	![] [R] 1813
![] [t] 1792	![] [G] 1803	![] [S] 1814
![] [u] 1793	![] [H] 1804	![] [T] 1015
![] [W] 1704	![] ![]	![] [U] 1816
![] [X] 1795	![] [I] 1805	![] ![]
![] [y] 1796	![] [K] 1806	![] [a] 1817
![] ![]	![] [L] 1807	![] [b] 1818
![] [A] 1797	![] [M] 1808	![] [c] 1819
![] [B] 1798	![] [N] 1809	![] [d] 1820
![] [C] 1799	![] [O] 1810	![] [e] 1821
![] [D] 1800	![] [P] 1811	![] [f] 1822
![] [E] 1801	![] [Q] 1812	![] [g] 1823

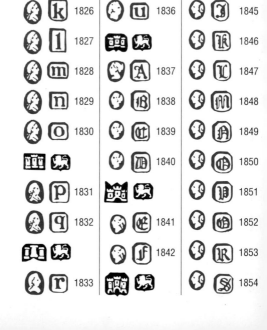

h 1824	S 1834	B 1843
i 1825	t 1835	H 1844
k 1826	u 1836	J 1845
l 1827		K 1846
m 1828	A 1837	L 1847
n 1829	B 1838	M 1848
o 1830	C 1839	A 1849
	D 1840	B 1850
p 1831		P 1851
q 1832	E 1841	O 1852
	F 1842	R 1853
r 1833		S 1854

	1855		1866		1877
	1856		1867		1878
			1868		1879
A	1857	N	1869	D	1880
B	1858	O	1870	E	1881
C	1859	P	1871	F	1882
D	1860	Q	1872		
E	1861	R	1873		
F	1862	S	1874		
G	1863	T	1875		
H	1864	U	1876		
I	1865				

Exeter Assay Office closed in 1883

EXETER MAKERS' MARKS

AR	Peter Arno	**RF**	Richard Ferris
DC	Daniel Coleman	**Ri**	Edward Richards
EI	John Elston	**RS**	Richard Sams
FR	Richard Freeman	**SB**	Samuel Blachford
GF	George Ferris	**SL**	Simon Lery
GT	George Turner	**Sy**	Pentycost Symonds
IB	John Buck	**TB**	Thomas Blake
IE	John Elston	**TE**	Thomas Eustace
IP	Isaac Parkin	**TR**	George Trowbridge
IW	John Williams	**TS**	Thomas Sampson
JH	Joseph Hicks	**Wi**	Richard Wilcocks
JO	John Osmont	**WP**	William Parry or William Pearse or William Pope
JS	John Stone or James Strong		
JW	James Williams	**WRS**	W R Sobey
JW & Co	James Whipple & Co	**WW**	William West
Mo	John Mortimer		

DUBLIN

Dublin's Goldsmiths' Company was given its charter in 1638, although silver had been made there long before and the Sterling standard was adopted as early as 1606. Dublin silver is known for a high standard of decorative workmanship.

The mark of origin is a harp crowned. Originally it also doubled as the standard mark. Up to 1719 two different versions of the harp crowned may be found, as shown in the tables. From 1731 the figure of Hibernia was added to show that duty had been paid. However, from 1807 when the sovereign's head mark was adopted as a duty mark (up to 1890, as in England), Hibernia was kept, and in time became regarded as the mark of origin for Dublin, while the harp crowned came to be regarded as the Sterling standard mark.

The date letter sequence began in 1638. Dublin used a 20-letter sequence (A to U omitting J) until 1678, when a 23 or 24-letter sequence was introduced (omitting J, V and sometimes I). There was an aborted sequence of A to C in 1717–19. In 1821 a 25-letter sequence was adopted (omitting J). The date letter was changed in June until 1932, since when it has changed in January.

As Dublin is in the Irish Republic, it was not affected by the United Kingdom's Hallmarking Act of 1973.

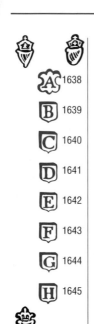

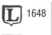

 1638

B 1639

C 1640

D 1641

E 1642

F 1643

G 1644

H 1645

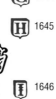

I 1646

K 1647

L 1648

M 1649

N 1650

O 1651

P 1652

Q 1653

R 1654

S 1655

T 1656

U 1657

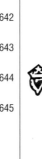

a 1658

b 1659

c 1660

d 1661

e 1662

f 1663

g 1664

h 1665

i 1666

k 1667

l 1668

m 1669

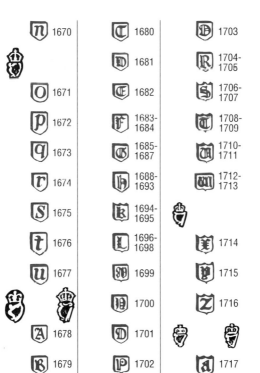

𝕟 1670	𝕋 1680	𝔇 1703
𝕆 1671	𝔇 1681	ℝ 1704-1705
𝕡 1672	𝔈 1682	𝔖 1706-1707
𝕢 1673	𝔉 1683-1684	𝕋 1708-1709
𝕣 1674	𝔊 1685-1687	𝔐 1710-1711
𝕤 1675	𝕙 1688-1693	𝔚 1712-1713
𝕥 1676	𝕜 1694-1695	
𝕦 1677	𝕃 1696-1698	𝕏 1714
𝔸 1678	𝕎 1699	𝕐 1715
𝔹 1679	𝕍 1700	𝕫 1716
	𝔇 1701	𝕒 1717
	𝕡 1702	

 1718

 1719

 1720

 1721

1722

1723

1724

1725

1726

1727

1728

 1729

1730

1731

1732

1733

1734

1735

1736

1737

1738

1739

Alternative version of the crowned harp used 1739 to 1748

 1740

 1740

 1741–1742

 1741–1742

 1743–1744

 1745

 1746

 1747

 B 1748

 C 1749

 D 1750

 E 1751

E 1751

F 1752

Alternative version
of Hibernia used
1751 to 1752

 G 1753

 H 1754

I 1757

K 1758

L 1759

 M 1760

 N 1761

 O 1762

 P 1763

 Q 1764

R 1765

 S 1766

 T 1767

 U 1768

 W 1769

 X 1770

 Y 1771

Z 1772

 A 1773

 B 1774

 C 1775

 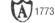 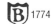 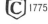 D 1776

 E 1777

 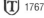

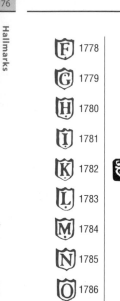

F 1778	R 1789	C 1799
G 1779	S 1790	D 1800
H 1780	T 1791	E 1801
I 1781	U 1792	F 1802
K 1782		G 1803
L 1783	W 1793	H 1804
M 1784	X 1794	I 1805
N 1785	Y 1795	K 1806
O 1786	Z 1796	L 1807
P 1787	A 1797	M 1808
Q 1788	B 1798	N 1809

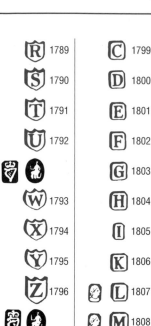

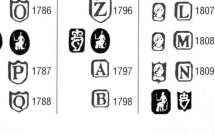

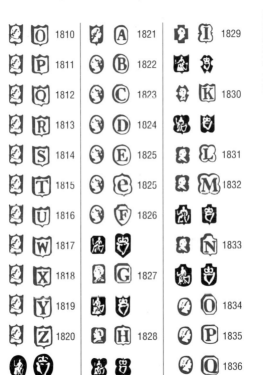

		1810			1821			1829
		1811			1822			
		1812			1823			1830
		1813			1824			
		1814			1825			1831
		1815			1825			1832
		1816			1826			
		1817						1833
		1818			1827			
		1819			1828			1834
		1820						1835
								1836

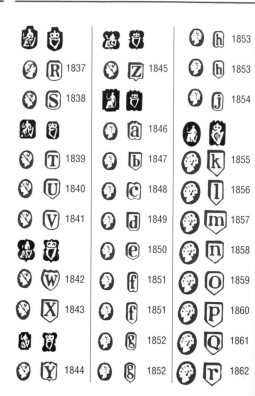

						1853		
	R	1837		Z	1845			1853
	S	1838						1854
				a	1846			
	T	1839		b	1847		k	1855
	U	1840		c	1848		l	1856
	V	1841		d	1849		m	1857
				e	1850		n	1858
	W	1842		f	1851		O	1859
	X	1843		f	1851		P	1860
				g	1852		Q	1861
	Y	1844		g	1852		r	1862

 1863

 1864

 1865

 1866

 1867

 1868

 1869

 1870

 1871

 1872

 1873

 1874

 1875

 1876

 1877

 1878

 1879

 1880

 1881

 1882

1883

1884

 1885

 1886

 1887

 1888

 1889

 1890

 1891

 1892

 1893

 1894

 1895

🅐 1896	🅐 1908	🅓 1919
🅑 1897	🅞 1909	🅔 1920
🅒 1898	🅟 1910	🅕 1921
🅓 1899	🅠 1911	🅖 1922
🅔 1900	🅡 1912	🅗 1923
🅕 1901	🅢 1913	🅘 1924
🅖 1902	🅣 1914	🅚 1925
🅗 1903	🅤 1915	🅛 1926
🅗 1904		🅜 1927
🅚 1905	🅐 1916	🅝 1928
🅛 1906	🅑 1917	🅞 1929
🅜 1907	🅒 1918	🅟 1930–1931

The date letter was changed on 1 June up to 1931. The Q of 1932 and all subsequent letters began on 1 January

 1940

 1941

 A 1942

 B 1943

 C 1944

 D 1945

 E 1946

 F 1947

 G 1948

 H 1949

I 1950

J 1951

K 1952

L 1953

M 1954

N 1955

O 1956

P 1957

Q 1958

R 1959

S 1960

T 1961

 1932 Q

1933 R

1934 S

1935 T

1936 U

V 1937

W 1938

X 1939

 1962

 1963

 1964

 1965

 1966

Special 'Sword of Light' mark used to commemorate 50th anniversary of 1916 Rising, in 1966

 1967

 1968

1969

1970

1971

1972

 1973

Special mark used in 1973 showing Gleninsheen Collar, to commemorate Ireland's entry into the EEC

1974

 1975

1976

1977

1978

1979

1980

1981

1982

 1983

 1984

 1985

 1986

 1987

Special shield used in 1907 to commemorate the 350th anniversary of the Goldsmiths' Company of Dublin

 1988

Special mark used in 1988 to commemorate the Dublin City Millennium Year

 1989

 1990

 1991

 1992

 1993

 1994

 1995

 1996

 1997

 1998

 1999

2000

2001

 2002

DUBLIN MAKERS' MARKS

AB	Alexander Brown	**JD**	James Douglas
AL	Antony Lefebure	**JP**	John Power
AR	Alexander Richards	**J.P**	John Pittar
BM	Bartholomew Mosse	**JS**	James Smythe
CM	Charles Marsh	**MH**	Michael Hewitson
CT	Christopher Thompson	**MN**	Michael Nowlan
DE	Daniel Egan	**MW**	Matthew West
DK	David King	**PM**	Patrick Moore
EB	Edward Barrett	**PW**	Peter Walsh
EC	E Crofton	**RC**	Robert Calderwood
EF	Esther Forbes	**RS**	Richard Sawyer
EJ	Edmund Johnson	**RW**	Richard Williams or Robert William
EP	Edward Pome	**SN**	Samuel Neville
GA	George Alcock	**SW**	Samuel Walker
GW	George Wheatley	**TJ**	Thomas Jones
HM	Henry Matthews	**TK**	Thomas Kinslea
IB	John Buckton	**TP**	Thomas Parker
IC	John Cuthbert or John Christie	**TS**	Thomas Slade
IF	John Fry	**TW**	Thomas Walker
IH	John Hamilton	**TWY+**	Edward Twycross
II	Joseph Jackson	**WA**	William Archdall
IL	John Laughlin	**WC**	William Cummins
ILB	John Le Bas	**WL**	William Lawson
IP	John Pittar	**WN**	William Nowlan
IS	James Scott	**WR**	William Rose
		WW	William Williamson

NEWCASTLE '

Silver was assayed in Newcastle from the mid-17th century, becoming systematic in 1702. Newcastle is known for domestic silver, tankards and two-handled cups. A curiosity of Newcastle is the presence of three known women silversmiths.

The town mark depicted three separate castles. From 1702 to 1719 the Britannia mark and the lion's head erased were in use. From 1720 these were replaced with the leopard's head and the lion passant. From 1721 to 1727 the lion passant usually faced to the right. The sovereign's head duty mark was used from 1784 to 1883.

The date letter sequence began in 1702. Newcastle used a 19-letter sequence (A to T generally omitting J) until 1759, when a 24-letter sequence was introduced (omitting J and V). The date letter was changed in May.

The Newcastle Assay Office was closed in 1884.

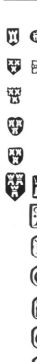

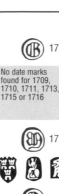

circa 1658-1670

circa 1672-1684

circa 1685-1694

circa 1696

circa 1700

 1708

No date marks found for 1709, 1710, 1711, 1713, 1715 or 1716

 1712

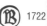 1714

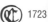 1717

 1718

 1719

 1720

1721

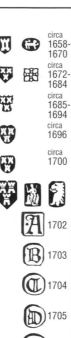

A 1702

B 1703

C 1704

D 1705

E 1706

F 1707

Various shapes of lions passant and shields were used 1721–1728. Sometimes the lion faced left

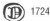

B 1722

C 1723

D 1724

E 1725

F 1726

G 1727

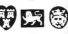 1728

 1729

® 1730	1741	1753
1731	1742	1754
1732	1743	1755
1733	1744	1756
1734	1745	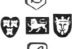 1757
1735	1746	1758
1736	1747	
1737	1748	1759
1738	1749	1760–1768
1739	1750	1769
	1751	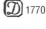 1770
1740	1752	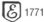 1771

 1772

 1773

 1774

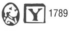 1775

K 1776

L 1777

M 1778

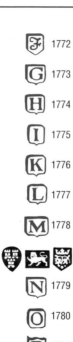 1779

O 1780

P 1781

Q 1782

R 1783

S 1784

T 1785

U 1786

W 1787

X 1788

Y 1789

Z 1790

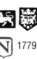

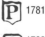 A 1791

B 1792

C 1793

 1794

 1795

 1796

G 1797

 1798

 1799

 1800

 K 1800

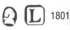 L 1801

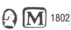 M 1802

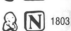 N 1803

O 1804

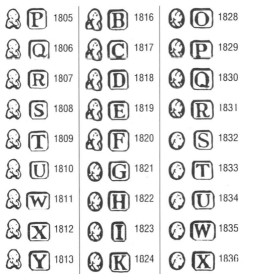

P 1805	B 1816	O 1828
Q 1806	C 1817	P 1829
R 1807	D 1818	Q 1830
S 1808	E 1819	R 1831
T 1809	F 1820	S 1832
U 1810	G 1821	T 1833
W 1811	H 1822	U 1834
X 1812	I 1823	W 1835
Y 1813	K 1824	X 1836
Z 1814	L 1825	Y 1837
	M 1826	Z 1838
A 1815	N 1827	

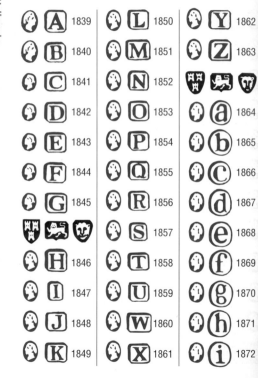

A 1839	L 1850	Y 1862
B 1840	M 1851	Z 1863
C 1841	N 1852	
D 1842	O 1853	a 1864
E 1843	P 1854	b 1865
F 1844	Q 1855	c 1866
G 1845	R 1856	d 1867
	S 1857	e 1868
H 1846	T 1858	f 1869
I 1847	U 1859	g 1870
J 1848	W 1860	h 1871
K 1849	X 1861	i 1872

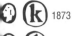 1873

1874

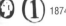 1875

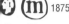 1876

 1877

 1878

 1879

 1880

 1881

 1882

 1883

Newcastle Assay
Office was closed
down in 1884

NEWCASTLE MAKERS' MARKS

AK	Alexander Kelty	**IR**	John Robertson
AR	Anne Robertson	**IS**	John Stoddart
Ba	Francis Batty	**IW**	John Walton
Bi	Eli Bilton	**La**	John Langwith
Bu	John Buckle	**L & S**	Lister & Sons
CJR	Christian Reid Junior	**MA**	Mary Ashworth
CR	Christian & David	**Ra**	John Ramsay
DR	Reid	**R & D**	Robertson & Darling
CR	Christian Reid &	**RM**	Robert Makepeace
IS	John Stoddart	**RP**	Pinkney & Scott
DC	David Crawford	**RS**	
DD	David Darling	**RS**	Robert Scott
DL	Dorothy Langlands	**TP**	Thomas Partis
DR	David Reid	**TS**	Thomas Sewill
FB	Francis Batty	**TW**	Thomas Watson
GB	George Bulman	**WL**	William Lister
IC	Isaac Cookson	**WL**	Lister & Sons
IK	James Kirkup	**CL**	
IL	John Langlands	**WL**	
IR	& John Robertson	**Yo**	John Younghusband
IM	John Mitchison		

CHESTER

From the early 15th century, Chester had a guild of goldsmiths which supervised the making, assaying and selling of plate, although marking was not regulated here until the late 17th century. Chester is known for small items such as beakers and creamers.

The mark of origin was the city arms, a sword between three wheatsheaves (gerbes). From 1701 this changed to three wheatsheaves halved with three lions halved. From 1701 to 1718 the figure of Britannia and the lion's head erased were used as the standard mark. From 1719 the leopard's head crowned and the lion passant were used. From 1839 the leopard's head was omitted. The sovereign's head duty mark was in use from 1784 to 1890.

The date letter sequence began in 1701, and was of irregular length, varying from 21 to 25 letters. The letter was changed each July until 1839, then in August until 1890, then in July again until the office was closed down in 1962.

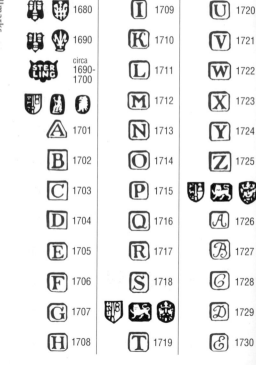

		1680			1709			1720
		1690			1710			1721
	circa 1690-1700				1711			1722
					1712			1723
		1701			1713			1724
		1702			1714			1725
		1703			1715			
		1704			1716			1726
		1705			1717			1727
		1706			1718			1728
		1707						1729
		1708			1719			1730

STER LING

ℱ 1731	𝒮 1743	ⓒ 1753
𝒢 1732	𝒯 1744	d 1754
ℋ 1733	𝒰 1745	e 1755
𝒥 1734	𝒱 1746	f 1756
𝒦 1735	𝒲 1747	G 1757
ℒ 1736	𝒳 1748	h 1758
ℳ 1737	𝒴 1749	i 1759
𝒩 1738	𝒳 1749	k 1760
𝒪 1739	𝒵 1750	l 1761
𝒫 1740	🛡🦁🛡	m 1762
𝒬 1741	a 1751	n 1763
ℛ 1742	b 1752	O 1764

P 1765	a 1776	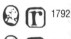 l 1786
Q 1766	b 1777	m 1787
R 1767	c 1778	n 1788
S 1768	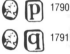 1779	o 1789
T 1769	d 1779	p 1790
T 1770	e 1780	q 1791
U 1771	f 1781	r 1792
V 1772	g 1782	s 1793
W 1773	h 1783	t 1794
X 1774	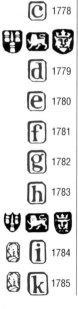	u 1795
Y 1775	i 1784	v 1796
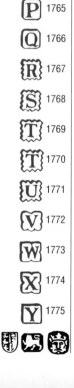	k 1785	

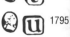

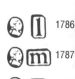
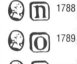
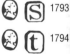

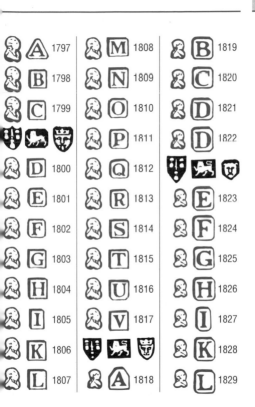

| | | | | | | | | |
|---|---|---|---|---|---|
| A | 1797 | M | 1808 | B | 1819 |
| B | 1798 | N | 1809 | C | 1820 |
| C | 1799 | O | 1810 | D | 1821 |
| | | P | 1811 | D | 1822 |
| D | 1800 | Q | 1812 | | |
| E | 1801 | R | 1813 | E | 1823 |
| F | 1802 | S | 1814 | F | 1824 |
| G | 1803 | T | 1815 | G | 1825 |
| H | 1804 | U | 1816 | H | 1826 |
| I | 1805 | V | 1817 | I | 1827 |
| K | 1806 | | | K | 1828 |
| L | 1807 | A | 1818 | L | 1829 |

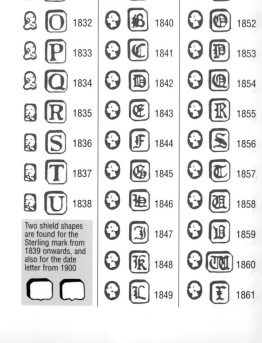

		1830
		1831
		1832
		1833
		1834
		1835
		1836
		1837
		1838

Two shield shapes are found for the Sterling mark from 1839 onwards, and also for the date letter from 1900

	1839
	1840
	1841
	1842
	1843
	1844
	1845
	1846
	1847
	1848
	1849

	1850
	1851
	1852
	1853
	1854
	1855
	1856
	1857
	1858
	1859
	1860
	1861

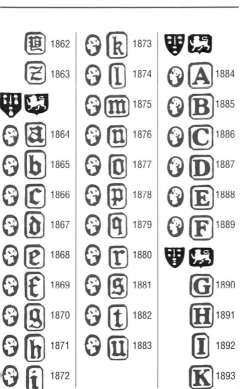

𝐁 1862	😊 k 1873	
𝐙 1863	😊 l 1874	😊 A 1884
	😊 m 1875	😊 B 1885
😊 a 1864	😊 n 1876	😊 C 1886
😊 b 1865	😊 o 1877	😊 D 1887
😊 c 1866	😊 p 1878	😊 E 1888
😊 d 1867	😊 q 1879	😊 F 1889
😊 e 1868	😊 r 1880	
😊 f 1869	😊 s 1881	G 1890
😊 g 1870	😊 t 1882	H 1891
😊 h 1871	😊 u 1883	I 1892
😊 i 1872		K 1893

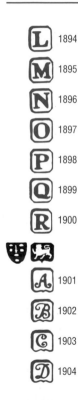

L 1894

M 1895

N 1896

O 1897

P 1898

Q 1899

R 1900

 1901

A 1901

B 1902

C 1903

D 1904

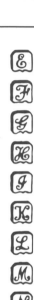

E 1905

F 1906

G 1907

H 1908

I 1909

K 1910

L 1911

M 1912

N 1913

O 1914

P 1915

Q 1916

R 1917

S 1918

T 1919

U 1920

V 1921

W 1922

X 1923

Y 1924

Z 1925

a 1926

b 1927

 1928

 1929

 1930

 1931

 1932

 1933

 1934

 1935

 1936

 1936

 1937

 1937

 1938

 1939

 1940

 1941

 1942

 1943

 1944

 1945

 1946

 1947

 1948

 1949

 1950

 1951

 1952

 1953

 1949

 1950

 1951

 1952

 1953

 1958

 1959

 1961

Chester Assay Office closed in August 1962

1960

1962

CHESTER MAKERS' MARKS

B & F	Matthew Boulton & James Fothergill	JA	John Adamson
Bi	Charles Bird	JC	James Conway or John Coakley
BP	Benjamin Pemberton	JL	John Lowe
Bu	Nathaniel Bullen	JS	John Sutters
Du	Bartholomew Duke	NC	Nicholas Cunliffe
EM	Edward Maddock	Pe	Peter Pemberton
FB	Francis Butt	RG	Robert Green
GL	George Lowe	RI	Robert Jones
GR	George Roberts	RL	Robert Lowe
GW	George Walker	RP	Richard Pike
IB	James Barton	RR	Richard Richardson
IG	John Gilbert	TM	Thomas Maddock
IL TL	John & Thomas Lowe	WH	William Hull
		WP	William Pugh
IR	John Richards	WR	William Richardson
IW	Joseph Walley		

GLASGOW

Silver was assayed in Glasgow from the late 17th century, although in the years 1784–1819 Glasgow silverware was mainly assayed in Edinburgh. In the latter year the Glasgow Goldsmiths' Company was formed and several changes were made in the marks.

The Glasgow mark of origin was a tree with a bird in the upper branches, a bell hanging from a lower branch and a fish (with a ring in its mouth) laid across the trunk. From 1819 a lion rampant was adopted as the Sterling standard mark, and in 1914 the Scottish thistle was added. Also from 1819, the Britannia standard (and appropriate mark) were in optional use. Up to 1784 the maker's mark was stamped twice, once on each side of the mark of origin. The sovereign's head duty mark was used from 1819 to 1890.

The date letter sequence began in 1681. After about the first 25 years, regular cycles were abandoned and the letters 's' and 'o' were commonly used until 1819, when a full 26-letter sequence was introduced. The date letter was changed annually in July.

The Glasgow Assay Office closed in 1964.

Date letters were used 1681–1709, but then not again until 1819

The maker's mark was stamped on both sides of the Glasgow town mark up to 1784

 a 1681

 C 1683

 1685

 1689

 K 1690

 1694

1696

S 1698

 t 1699

 1700

 1701

 1704

 1705

 B circa 1707

 D circa 1709

 circa 1717

The letter S was used probably as a Sterling mark

 S circa 1728

 S circa 1734

 S circa 1743

 S circa 1747

 S circa 1756

 circa 1757

 S circa 1758

 E circa 1763

 S circa 1773

 S circa 1773

 O circa 1776

 S circa 1780

 S circa 1781

 S circa 1783

 circa 1784

 1811

 1819

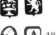

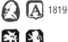 B 1820

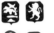 C 1821

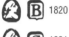 D 1822

 E 1823

 F 1824

 G 1825

H 1826

 I 1827

J 1828

 K 1829

L 1830

M 1831

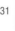 N 1832

O 1833

P 1834

 Q 1835

R 1836

 S 1837

T 1838

U 1839

V 1840

W 1841

 X 1842

Y 1843

Z 1844

 A 1845

 B 1846

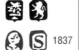 C 1847

D 1848

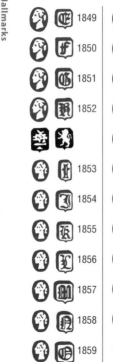

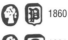 1849

 1850

 1851

 1852

 1853

 1854

 1855

 1856

 1857

 1858

 1859

 1860

1861

1862

1863

1864

1865

1866

1867

1868

1869

 1870

 1871

 1872

 1873

 1874

 1875

1876

1877

1878

1879

1880

1881

 1882

1883	1895	1906
1884	1896	1907
1885	1897	1908
1886	1898	1909
1887	1899	1910
1888	1900	1911
1889		1912
1890	1913	
1891		1914
1892		1915
1893		1916
1894		

 1917
 1918
1919
1920
1921
1922

 1923
1924
1925
1926
1927

 1928
 1929
 1930
 1931
 1932
 1933
 1934
1935
1936
1937

 1938
 1939
 1940
 1941
 1942
 1943
 1944
 1945
 1946
 1947
1948

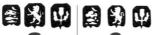

1949 F 1954 N 1960

B 1950 1955 O 1961

C 1951 1956 P 1962

 J 1957 R 1963

L 1952 L 1958

 e 1953 m 1959

Glasgow Assay
Office closed in
1964

GLASGOW MAKERS' MARKS

AM	Alexander Mitchell	**JM**	John Mitchell or J Murray
A & T	Aird & Thompson	**LFN**	Luke Newlands
DCR	Duncan Rait	**PA**	Peter Arthur
DMcD	David McDonald	**RG**	Robert Gray &
JC	James Crichton	**& S**	Sons
JL	John Law	**WP**	William Parkins

BIRMINGHAM

The Birmingham Assay Office opened in 1773, after which the city grew quickly in importance as a centre for silversmithing.

The mark of origin is an anchor (struck lying on its side for gold and platinum). It appeared very consistently with the lion passant standard mark. The sovereign's head duty mark was in use from 1784 to 1890.

The date letter sequence began in 1773 (in which year the letter A appeared in three different shapes of shield). Birmingham used 25 and 26-letter sequences alternately (omitting J). The date letter was changed in July until 1975, since when all British date letters have been standardised and changed on 1 January. In the same year, platinum was first assayed here.

A special commemorative mark was struck in 1973 to mark the bicentenary of the Birmingham Assay Office. The office is still in operation today.

 A 1773

A 1773

A 1773

B 1774

C 1775

D 1776

E 1777

F 1778

G 1779

H 1780

I 1781

K 1782

L 1783

 M 1784

N 1785

O 1786

P 1787

Q 1788

R 1789

S 1790

T 1791

U 1792

V 1793

 W 1794

X 1795

Y 1796

Z 1797

The duty on silver was doubled in 1797, and so for a short time the king's head was stamped twice

a 1798

b 1799

C 1800

d 1801

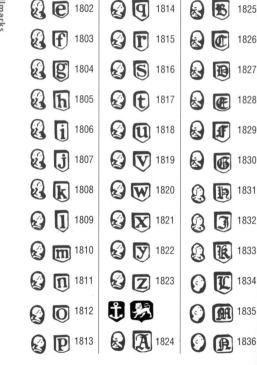

e	1802	q	1814	B	1825		
f	1803	r	1815	C	1826		
g	1804	s	1816	D	1827		
h	1805	t	1817	E	1828		
i	1806	u	1818	F	1829		
j	1807	v	1819	G	1830		
k	1808	w	1820	H	1831		
l	1809	x	1821	J	1832		
m	1810	y	1822	K	1833		
n	1811	z	1823	L	1834		
o	1812			M	1835		
p	1813	A	1824	A	1836		

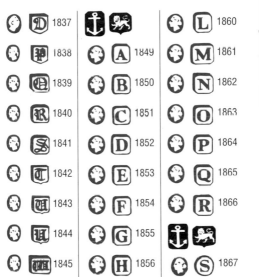

🜨	D̄	1837	⚓ 🦁		🜨 L	1860
🜨	P̄	1838	🜨 A	1849	🜨 M	1861
🜨	Q̄	1839	🜨 B	1850	🜨 N	1862
🜨	R̄	1840	🜨 C	1851	🜨 O	1863
🜨	S̄	1841	🜨 D	1852	🜨 P	1864
🜨	T̄	1842	🜨 E	1853	🜨 Q	1865
🜨	Ū	1843	🜨 F	1854	🜨 R	1866
🜨	V̄	1844	🜨 G	1855	⚓ 🦁	
🜨	W̄	1845	🜨 H	1856	🜨 S	1867
🜨	X̄	1846	🜨 I	1857	🜨 T	1868
🜨	Ȳ	1847	🜨 J	1858	🜨 U	1869
🜨	Z̄	1848	🜨 K	1859	🜨 V	1870

(w) 1871	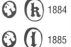 1882	(r) 1891
(x) 1872	anchor & lion	(s) 1892
(Y) 1873	(i) 1883	(t) 1893
(Z) 1874	(k) 1884	(u) 1894
anchor & lion	(l) 1885	(v) 1895
(a) 1875	(m) 1886	(m) 1896
(b) 1876	(n) 1887	(x) 1897
(c) 1877	(o) 1888	(y) 1898
(d) 1878	(p) 1889	(z) 1899
(e) 1879	(q) 1890	anchor & lion
(f) 1880	The queen's head duty mark was not used after 1890	(a) 1900
(g) 1881		(b) 1901

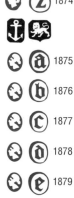
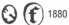

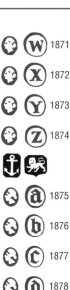

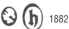
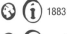

 1902

 1903

 1904

 1905

 1906

 1907

 1908

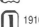 1909

 1910

 1914

 1915

 1916

 1917

 1918

 1919

 1920

 1921

 1922

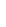 1923

 1924

 1925

 1926

 1927

 1928

 1929

 1930

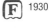 1931

 1932

 1933

 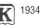 1934

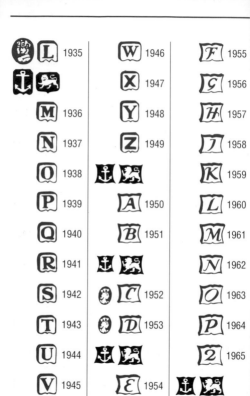

L 1935	W 1946	F 1955
M 1936	X 1947	G 1956
N 1937	Y 1948	H 1957
O 1938	Z 1949	J 1958
P 1939	A 1950	K 1959
Q 1940	B 1951	L 1960
R 1941		M 1961
S 1942	C 1952	N 1962
T 1943	D 1953	O 1963
U 1944		P 1964
V 1945	E 1954	2 1965

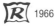 1966

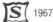 1967

 1968

 1969

 1970

 1971

 1972

In 1973 the bicentenary of the Birmingham Assay Office was commemorated by a special town mark

 1973

 1974

New letter sequence commenced from 1 January 1975, in accordance with the Hallmarking Act passed in 1973

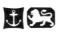

 1975

 1976

 1977

 1978

 1978

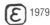 1979

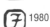 1980

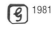 1981

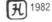 1982

 1983

 1984

 1985

 1986

 1987

\mathcal{R}	1991	\mathcal{V}	1995	Z	1999
\mathcal{S}	1992	\mathcal{W}	1996	a	2000
\mathcal{T}	1993	\mathcal{X}	1997	b	2001
\mathcal{U}	1994	\mathcal{Y}	1998	C	2002

BIRMINGHAM MAKERS' MARKS

C & B	Cocks & Bettridge	**MB**	Matthew Boulton
E & CoLd	Elkington & Co	**MB IF**	Matthew Boulton & John Fothergill
EM & Co	Elkington Mason & Co	**ML**	Matthew Linwood
ES	Edward Smith	**NM**	Nathaniel Mills
ET	Edward Thomasson	**P & T**	William Postan & George Tye
FC	Francis Clark	**REA**	Robinson, Edkins & Aston
GU	George Unite		
GW	Gervase Wheeler	**SP**	Samuel Pemberton
H & T	Hilliard & Thomasson	**T & P**	Joseph Taylor & John Perry
IB	John Bettridge	**TS**	Thomas Shaw
IS	John Shaw	**TW**	Thomas Willmore
IT	Joseph Taylor	**WF**	William Fowke
JW	Joseph Willmore	**Y & W**	Yapp & Woodward
L & Co	John Lawrence & Co		

SHEFFIELD

The Assay Office was opened in 1773. Sheffield is best known for the production of candlesticks.

The mark of origin on Sheffield silver was the crown until 1975, since when it has been a York rose. The standard mark was a lion passant. The sovereign's head duty mark was in use from 1784 to 1890.

From 1780 to 1853 small items were marked with a special stamp on which the crown mark of origin and the date letter were combined.

The application of date letters began in September 1773 with the letter E, changing every July. The choice of letter was quite random until 1824, when Sheffield began to use a regular 25-letter alphabetical sequence (omitting J). In 1975 the standard British date letter sequence was imposed, with the letter being changed on 1 January each year. In the same year, platinum was first assayed at Sheffield.

The Sheffield Assay Office is still in operation.

 1773

 1774

 1775

 1776

 1777

 1778

 1779

For alternative marks used on small objects from 1780 to 1853, see pages 123-125

 1780

In the period 1780 to 1823, the crown and lion passant varied slightly, eg:

Also varied in years 1824–43, but crown is in a square shield

 1781

 1782

 1783

 1784

 1785

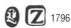 1786

 1787

 1788

 1789

 1790

 1791

 1792

 1793

 1794

 1795

 1796

 1797

From 15 July 1797 for nine months, the duty on silver was doubled and so the king's head was stamped twice

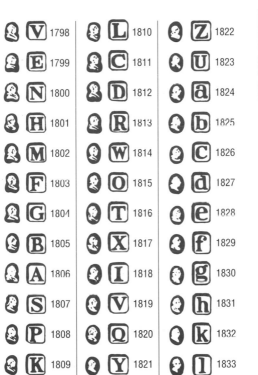

V 1798	L 1810	Z 1822
E 1799	C 1811	U 1823
N 1800	D 1812	a 1824
H 1801	R 1813	b 1825
M 1802	W 1814	C 1826
F 1803	O 1815	d 1827
G 1804	T 1816	e 1828
B 1805	X 1817	f 1829
A 1806	I 1818	g 1830
S 1807	V 1819	h 1831
P 1808	Q 1820	k 1832
K 1809	Y 1821	l 1833

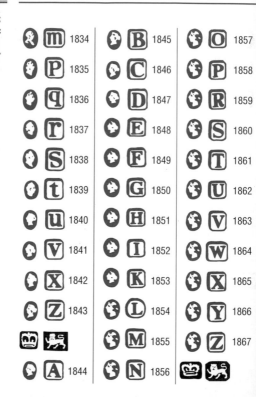

m 1834	B 1845	O 1857
P 1835	C 1846	P 1858
q 1836	D 1847	R 1859
r 1837	E 1848	S 1860
s 1838	F 1849	T 1861
t 1839	G 1850	U 1862
u 1840	H 1851	V 1863
v 1841	I 1852	W 1864
X 1842	K 1853	X 1865
Z 1843	L 1854	Y 1866
	M 1855	Z 1867
A 1844	N 1856	

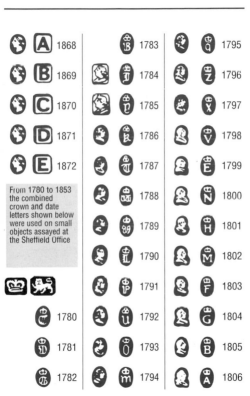

🌐 A	1868	🌐 B	1783	🌐 Q	1795	
🌐 B	1869	🌐 T	1784	🌐 Z	1796	
🌐 C	1870	🌐 P	1785	🌐 X	1797	
🌐 D	1871	🌐 R	1786	🌐 V	1798	
🌐 E	1872	🌐 T	1787	🌐 E	1799	
		🌐	1788	🌐 N	1800	
		🌐	1789	🌐 H	1801	
		🌐 L	1790	🌐 M	1802	
🌐	1780	🌐 P	1791	🌐 F	1803	
🌐 D	1781	🌐 U	1792	🌐 G	1804	
🌐	1782	🌐 O	1793	🌐 B	1805	
		🌐 m	1794	🌐 A	1806	

From 1780 to 1853 the combined crown and date letters shown below were used on small objects assayed at the Sheffield Office

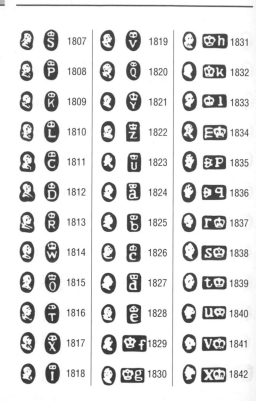

S 1807	V 1819	h 1831
P 1808	Q 1820	k 1832
K 1809	Y 1821	l 1833
L 1810	Z 1822	E 1834
C 1811	U 1823	P 1835
D 1812	a 1824	q 1836
R 1813	b 1825	r 1837
W 1814	c 1826	S 1838
O 1815	d 1827	t 1839
T 1816	e 1828	u 1840
X 1817	f 1829	V 1841
I 1818	g 1830	X 1842

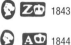 1843	1873	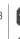 1885			
1844	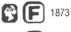 1874	1886			
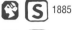 1845	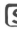 1875	1887			
1846	1876	1888			
1847	1877	1889			
1848	1878	1890			
1849	1879	1891			
1850	1880	1892			
1851	1881				
1852	1882				
1853	1883	1893			
	1884	1894			
		1895			

d 1896	**q** 1908	**b** 1919
e 1897	**r** 1909	**c** 1920
f 1898	**s** 1910	**d** 1921
g 1899	**t** 1911	**e** 1922
h 1900	**u** 1912	**f** 1923
i 1901	**v** 1913	**g** 1924
k 1902	**w** 1914	**h** 1925
l 1903	**x** 1915	**i** 1926
m 1904	**y** 1916	**k** 1927
n 1905	**z** 1917	**l** 1928
o 1906		**m** 1929
p 1907	**a** 1918	**n** 1930

1931	1941	
1932	1942	1952
1933		1953
	1943	1954
1934	1944	1955
1935	1945	1956
	1946	1957
1936	1947	1958
1937	1948	1959
1938	1949	1960
1939	1950	1961
1940	1951	

 1962

 1963

 1964

X 1965

 1966

Z 1967

 1968

 1969

 1970

 1971

E 1972

 1973

The 1773 date letter was used in 1973 to commemorate the Sheffield Assay Office bicentenary

 1974

New letter sequence commenced from 1 January 1975, in accordance with the Hallmarking Act passed in 1973

 1975

 1976

 1977

 1978

 1979

 1980

 1981

 1982

 1983

 1984

 1985

 1986

N 1987

Standards of pewter

The Pewterers' Company regulated the quality of the alloy, in much the same way as the Goldsmiths' Company assayed silver and gold. The three principal types of pewter are, in ascending order of quality:

- Ley pewter: 80% tin, 20% lead
- Trifle pewter: 82% or 83% tin, 17% or 18% antimony
- Plate pewter: 86% tin, 7% antimony, 3.5% copper, 3.5% bismuth

Quality marks

Ley and trifle pewter did not carry any marks of quality. Plate pewter was marked with a letter 'X' (denoting extraordinary ware), sometimes with a crown above it (**1**), or was stamped with the words 'hard metal' or 'superfine hard metal' (**2**). A rose and crown stamp (**3**) also indicated fine quality pewter. At first this mark was for export ware only, although by the 18th century it had become more generally used. From the late 17th century, the word 'London' was added to the rose and crown, but it was often used by provincial pewterers also, and so is no guarantee of provenance.

1 SUPERFINE HARD METAL 3

 2

Touch marks

By far the most important marks on pewter are the 'touch marks' or 'touches'. These identify the maker,

and take their name from official 'touch plates' on which they were stamped when being registered at Pewterers' Hall. The earliest touch plates dated from the beginning of the 15th century but were lost in the Great Fire of London in 1666. The practice of registering marks on the touch plates began again two years later and continued until 1824.

The marks do not appear on the touch plates in chronological order, having been punched in any empty space in a haphazard fashion. Five copper touch plates survive at the Pewterers' Company, but the corresponding register of makers has been lost, making individual identification impossible in many cases.

A maker's touch mark often consisted simply of his initials or name, but could also incorporate elaborate designs, sometimes with a play on words based on the man's name. Dates also occasionally form part of the mark, but they indicate the year when the touch was registered rather than the year the piece was made.

The size of the touch marks varies according to the size of the item on which they appear, but as a very general rule, early marks tend to be smaller than later ones.

Other marks

Good early pewter often bears elaborate ownership marks in a raised form, rather like a wax seal. Triads (a triangular formation) of letters stamped on the rim of a pewter plate are generally held to give the initials of the couple who owned it.

Small marks are also found on pewter in imitation of silver hallmarks, and usually consist of four shields (**1**). The symbols in the shields generally imitate genuine silver marks quite closely – for instance, the figure of Britannia, the lion passant and the leopard's head – presumably with the purpose of persuading the buyer that the item concerned contained real silver.

After 1826, tankards and measures used in taverns had to carry capacity marks. These were of local design until 1877, after which they were validated by an excise mark consisting of a crown over the monarch's initials and a code number, denoting the area in which inspection of capacity had been carried out (**2**).

1 2

SAMPLE TOUCH MARKS

The touch marks shown on pages 164–167 are a small selection of examples where identification of the maker is possible. They are taken from Touch Plates I and IV at Pewterers' Hall, and serve to illustrate the variety that exists among the hundreds of touch marks registered there. If the touch mark you are seeking is not included, you should consult one of the specialist reference works on pewter marks in your local library.

Note that 'master', 'warden', 'steward' and 'yeoman' were ranks and appointments within the guild structure of the Pewterers' Company.

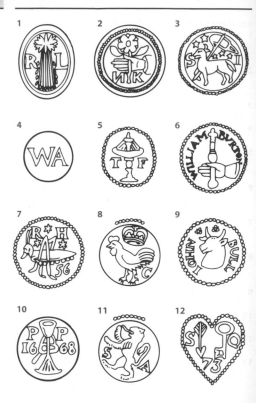

Sample marks from Touch Plates I

1 'RL' in an oval with a comet between the letters. Robert Lucas, who became a steward of the Pewterers' Company in 1651 and master in 1667.

2 'NK' in a beaded circle with a hand grasping a rose. Thought to be Nicholas Kelk, master in 1665, 1681 and 1686.

3 'SI' in a small beaded circle with a lamb and flag. Probably Samuel Jackson, working in the late 17thC.

4 'WA' in a small circle. Possibly William Austin or William Ayliffe, both working in the late 17thC.

5 'TF' in a beaded oval with a fountain. This is a pun on the maker's name, Thomas Fontaine or Fountain, who took up his livery in 1670.

6 'William Burton' in a beaded circle with a hand holding a sceptre. He was a warden in 1675 and 1680, and master in 1685.

7 'RH' in a beaded circle with a locust, three stars and the date [16]56. Ralph Hulls, warden in 1671 and 1677, master in 1682.

8 'C' in a beaded circle with a crown and cockerel. Another play on a name – Humphrey Cock, who took up his livery in 1679.

9 'John Bull' with a bull's head and two stars in a beaded circle. Late 17thC.

10 'PP' in a circle with a beacon and the date 1668. This could be the mark of Peter Parke or Peter Priest.

11 'SA' in a beaded circle with a lion rampant. Thought to be Sam Atley, who took his livery in 1667.

12 'SQ' in a beaded heart with an arrow and a key with the date [16]73. Thought to be Sam Quissenborough.

1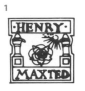
HENRY MAXTED

2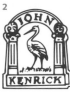
JOHN KENRICK

3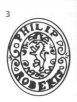
PHILIP ROBERTS

4
RC

5
Io PERRY

6
JOHN CARTWELL

7
JONATHAN LEACH

8
THOMAS GIFFIN

9
A JENNER

10
JAS APPLETON

11
C SWIFT

12
WOOD HILL

Sample marks from Touch Plates IV

1 'Henry Maxted' with pillars and the sun shining on a rose. Yeoman 1731.

2 'Iohn Kenrick' with a stork between two pillars. Yeoman 1737, warden 1754.

3 'Philip Roberts' with a lion rampant and a crescent. Yeoman 1738.

4 'RC' in a beaded circle with a lamb holding a crook. Thought to be a play on the name Robert Crooke, yeoman 1738.

5 'I Perry' with a female figure between pillars. Yeoman 1743, warden 1773.

6 'Iohn Hartwell' with a saltire and four castles. Yeoman 1736.

7 'Ionathan Leach' with a quartered shield of arms showing a rose, a sprig of laurel and a lamb and flag. The fourth quarter is illegible. Yeoman 1732.

8 'Thomas Giffin' with a dagger piercing a heart and a ducal coronet, all between pillars. Yeoman 1759.

9 'A Jenner' in a plain rectangle. Thought to be Anthony Jenner, yeoman 1754.

10 'Ino Appleton' with a still and a worm. Yeoman 1768, warden 1799, master 1800.

11 'C Swift' in an indented square with a thistle and a rose (the badge of Queen Anne). Yeoman 1770.

12 'Wood & Hill' with two sheep in a shield. Thought to be Thomas Wood (yeoman 1792) and Roger Hill (yeoman 1791).

Note: 'I' was often used for 'J'. 'Ino' and 'Jno' stand for 'John'.

4. POTTERY AND PORCELAIN

Unlike the strictly regulated hallmarks which appear on precious metals – and which give today's collector a foolproof means of identification – the marks that appear on pottery and porcelain are a far from reliable guide as to provenance.

Marks may be blurred and impossible to identify. A particular mark – say, an anchor – can indicate a wide variety of periods, factories and countries, and a true attribution can be given only by looking at the weight, colour, shape and pattern of the piece itself. The size and colour of the mark, as well as the way it was made, also have a bearing on its identification. Often marks have been used which imitated those of famous factories – for example, there were endless copies of the Meissen crossed swords. Marks have also been added fraudulently at later dates.

If a piece of pottery bears no mark at all, it does not mean the piece is necessarily of an early date, because much pottery from every period bears no mark at all. Confusion may also result from the fact that a mark may refer to a factory, to a potter or painter who worked there, or to a past owner of the piece. Dates, too, are not to be taken at face value, because they rarely give the date of actual manufacture. When incorporated into a mark, a date commonly indicates the year when the factory was established, or when a particular design was introduced. However, the design registration marks which were applied from 1842 do give reliable dates for British wares thereafter. There

were also a few factories which employed their own reliable dating systems, notably Sèvres, Derby, Minton and Wedgwood.

Pottery and porcelain are best understood by looking and touching, and the more you see and handle the various wares, the more of a feel you will get for them. Once you are more confident in your knowledge of the wares themselves, marks can be used as a very useful back-up. Nevertheless, approaching marks with a good deal of healthy suspicion is always to be recommended!

Pottery types

Pottery is made simply of clay, but many additions have been made to the clay mix to give added strength, and decorative glazes have been applied to enhance appearance. The following types are among the most common and important:

- **Creamware:** earthenware with a cream-coloured glaze, giving something of the impression of porcelain.
- **Delft:** Earthenware with a tin glaze, made in the 17th and 18th centuries
- **Faïence:** Tin-glazed earthenware.
- **Majolica:** Decorative tin-glazed earthenware first made in 15th-century Italy and copied in the 19th century.
- **Stoneware:** A strong non-porous ware made from adding sand or flint to the clay.
- **Ironstone:** Patented by Charles James Mason in 1813, using slag from iron furnaces to strengthen the wares.

Porcelain types

Porcelain was first made in China from the vital ingredients of kaolin (China clay) mixed with petuntse (China rock). It is recognised by its strength, its musical note when struck, and its translucent delicacy.

From the moment porcelain was first imported in the 15th century, it was a huge success in Europe and there were many attempts made to reproduce it in the West. The ingredients for the hard paste porcelain of the Chinese original were eventually found at Meissen in what is now Germany, and porcelain production began there in the early 18th century. The process was then imitated throughout Europe.

Other experiments to imitate porcelain produced soft-paste porcelain, which has a less hard, glittery glaze than hard-paste porcelain, as well as less strength.

METHODS OF APPLYING MARKS

The way in which a mark is made can help in attributing it to a particular factory (as can its colour). Where relevant, this has been noted in the pages which follow. There are four main methods:

- **Incising:** This is one of the earliest and simplest methods, whereby a mark is scratched into the clay before it is fired.

- **Impressing:** A stamp is used to press a mark into the unfired clay.

- **Underglaze painting or transfer-printing:** Until 1850 this appeared only in blue, after which other colours were used. As the name suggests, the mark was made before the final glaze was applied over it.

- **Overglaze marks:** These may be painted, transfer-printed or stencilled onto finished wares. This method is a particularly easy one for forgers to imitate.

A THUMBNAIL GUIDE TO ESTABLISHING DATES

- A printed mark signifies post-1800 manufacture
- Marks which include the royal arms appeared only after 1810
- Marks including the name of a pattern are also post-1810, and often much later
- The diamond registration mark indicates the period 1842–83 (*see page 172*)
- 'Limited' or 'Ltd' denotes 1860 onwards
- 'Trade mark' signifes 1862 onwards
- The practice of using 'Royal' followed by the manufacturer's name began in the mid-19th century
- 'Rd No' (Registered Number) was introduced in 1884
- The word 'England' was used from 1891 and 'Made in England' from early in the 20th century

REGISTERED DESIGN MARKS

The system of Registered Designs was devised in 1839 to protect the design of industrial products in much the same way that the patent laws protect inventions. There were two early layouts of Registered Design Marks, one in use from 1842 to 1867, the other from 1868 to 1883.

Mark layout 1842–67

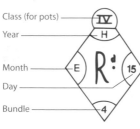

Class (for pots)
Year
Month
Day
Bundle

Year codes 1842–67	
A 1845	N 1864
B 1858	O 1862
C 1844	P 1851
D 1852	Q 1866
E 1855	R 1861
F 1847	S 1849
G 1863	T 1867
H 1843	U 1848
I 1846	V 1850
J 1854	W 1865
K 1857	X 1842
L 1856	Y 1853
M 1859	Z 1860

Mark layout 1868–83

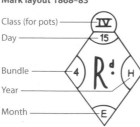

Class (for pots)
Day
Bundle
Year
Month

Year codes 1868–83	
A 1871	K 1883
C 1870	L 1882
D 1878	P 1877
E 1881	S 1875
F 1873	U 1874
H 1869	V 1876
I 1872	X 1868
J 1880	Y 1879

Month codes 1842–83

The same system of code letters was used to indicate the month of registration on both types of design mark layout shown opposite.

A	December	E	May	K	November
B	October	G	February	M	June
C/O	January	H	April	R	August
D	September	I	July	W	March

REGISTRATION NUMBERS

From 1884, the complex diamond-shaped registration mark was replaced by a simple registration numbering system. The abbreviation 'Rd No' (for Registered Number) often appeared before the number. The system remains in use today. The dates of numbers used in the early years are given in the table below.

Rd No	Year	Rd No	Year
1	1884	291241	1897
19754	1885	311658	1898
40480	1886	331707	1899
64520	1887	351202	1900
90483	1888	368154	1901
116648	1889	385088	1902
141273	1890	402913	1903
163767	1891	425017	1904
185713	1892	447548	1905
205240	1893	471486	1906
224720	1894	493487	1907
246975	1895	518415	1908
268392	1896	534963	1909

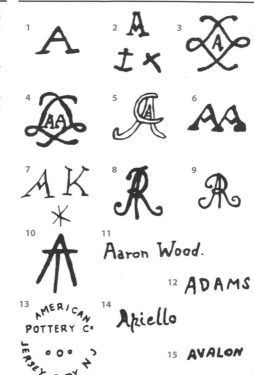

1

2

3

4

5

6

7

8

9

10

11 Aaron Wood.

12 ADAMS

13 AMERICAN POTTERY Cº JERSEY CITY N J o o o

14 Aҏiello

15 AVALON

A

1 Paris, France. Painted red/gold. c1795.

2 Bow, London, England. Red. c1765.

3 Sèvres, France. Mark and date letter for 1753. Date letters ran alphabetically until 1793 (AA from 1778) appearing inside or alongside the 'crossed Ls' in blue (or later red) enamel.

4 Sèvres, France, 1778.

5 Nymphenberg, Germany. Impressed or incised. c1745.

6 Arras, France. Soft-paste porcelain. 1770–90.

7 'De Ster' (The Star), artist A Kiell. Delft, Holland. c1763.

8 Helene Wolfsohn, decorator. Meissen, Germany. c1860.

9 Meissen, Germany. Painted underglaze blue. c1725.

10 Thomas Allen (painter). Wedgwood. 1875–1905.

11 Burslem, Staffordshire, England. Impressed. c1750.

12 Adams & Co, Tunstall, England. From c1790.

13 New Jersey, USA. Printed. Mid-19thC.

14 Capo-di-Monte, Italy. Incised. c1760.

15 Cartwright Bros, East Liverpool, Ohio, USA. 1880–1900.

1 *B*

2
BARR FLIGHT & BARR.
Royal Porcelain Works.
WORCESTER.
London-House.
Nº1 Coventry Street.

3

4 *B + B*

5

6

7 B&G

8 •B•H•

9 BL

10 M

11 B.S.&T.

12 BELPER POTTERY
DENBY

14 Booth

13 *6 lompot*

15 Bristoll

B

1 Flight & Barr, Worcester, England. Scratched in clay. 1793–1800. The most common Worcester marks are crescents, the letter W and copies of Chinese and Meissen marks.

2 Worcester. Printed. 1807–13. Later Worcester wares carry the full name.

3 Lille, France. Faïence. 1720–88.

4 Bristol, England. Painted. c1773.

5 Sèvres, France. 1754.

6 Bristol, England. 1773.

7 Bing & Grøndahl, Copenhagen, Denmark. 1853.

8 Knoller, Bayreuth, Germany. Faïence. c1730.

9 Limbach, Germany. Porcelain. Late 18thC.

10 Niderviller, France. 1744–80.

11 Barker, Sutton & Till, Burslem, Staffordshire, England. 1830–50.

12 Belper Pottery, Derbyshire, England. Stoneware. 1812.

13 'De Vergulde Bloompot' (The Golden Flowerpot), Delft, Holland. c1693.

14 Enoch Booth, Tunstall, Staffordshire, England. Impressed. c1750.

15 Bristol, England. Porcelain. c1750.

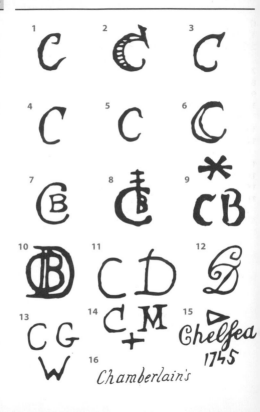

C

1 Nantes, France. c1780.

2–6 Caughley, England. Variations of the Caughley mark, printed or painted in underglaze blue 1772–95.

7 Bayreuth, Germany. Painted. 1744.

8 Castel Durante, Italy. c1570.

9 'De Ster' (The Star), C D Berg, Delft, Holland. c1720.

10 Coalport, Coalbrookdale, England. Hard-paste porcelain. Painted blue. c1825–50.

11 Limoges, France. Hard-paste porcelain. c1783.

12 Coalport, Coalbrookdale, England. Hard-paste porcelain. Painted blue. Early 19thC.

13 Leeds, England. c1760.

14 St Cloud, France. Faïence/porcelain. c1711.

15 Chelsea, London, England. Soft-paste porcelain. c1745.

16 Worcester, England. Red. 1788–1808.

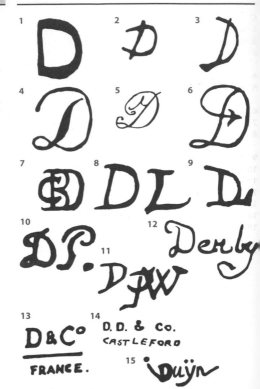

D

1 Davenport, England. Impressed. 1793–1882.

2 Derby, England. 1770–84.

3 Caughley, England. Hard-paste porcelain. Painted blue. c1750.

4 Derby, England. Soft-paste porcelain. Red. c1756.

5 John Donaldson (painter), Worcester, England. Porcelain. c1770.

6 Derby (Chelsea), England. c1782.

7 Coalport, Coalbrookdale, England. Painted blue. c1825–50.

8 William Littler, potter, Longton Hall, Staffordshire, England. 1750–60.

9 Louis Dorez, Nord, France. c1735.

10 Proskau, Silesia, Germany. Faïence. 1770–83.

11 'De Paauw' (The Peacock), Delft, Holland. Faïence. c1700.

12 Derby, England. Incised. c1750.

13 Limoges, France. c1875.

14 Castleford, England. Pottery. Impressed. c1790.

15 J van Duyn, 'De Porceleyne Schootel' (The Porcelain Dish), Delft, Holland. Faïence. Painted blue. c1764.

1 \mathcal{E}

2 \mathcal{E}

3 \mathcal{E}
1779

4 **EB**

5 $\mathcal{E}f$

6 E . I . B

7 E·L
1754

8 E
M+B
J760

9 E.Borne
1689

10 ENGLAND

11 ENOCH BOOTH
1757

12 Enoch Wood

13 E. NORTON
BENNINGTON
VT.

14 $\mathcal{F}\mathcal{T}$

15 E J

E

1 Elton Pottery, Somerset, England. 1880–90.

2 St Petersburg, Russia. 1762–96.

3 Derby, England. 1779.

4 Paris, France. c1800.

5 Moustiers, France. Faïence. 18thC.

6 Hanley, England. Impressed. 18thC.

7 Bow, London, England. c1754.

8 Michael Edkins and his wife, Bristol, England. Blue. c1760.

9 Henri Borne, Nevers, France. c1689.

10 From 1891, the word 'England' appeared on English wares.

11 Tunstall, Staffordshire, England. c1757.

12 Burslem, England. Impressed, moulded or incised. 1784–90.

13 Bennington, Vermont, USA. Impressed. c1882.

14 Ernst Teichert, Meissen, Germany. Late 19thC.

15 E Jacquemin, Fontainebleau, France. 1862–66.

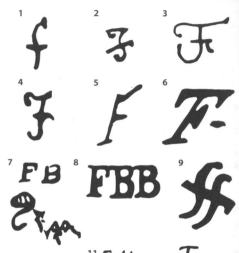

11 Fatto en Torino

12 Flight & Barr
Worcester
Manufacturers to their
Majesties

F

1 Rouen, France. Faïence. c1644.

2–3 Variations of mark of Furstenberg, Germany. 1760–70.

4 Jacob Fortling, Copenhagen, Denmark. Faïence. 1755–62.

5–6 Variations of mark of Bow, London. 1750–59.

7 François Boussemart, Lille, France. c1750.

8 Flight, Barr & Barr, Worcester. 1813–40.

9 Rouen, France. 1673–96.

10 Buen Retiro, Madrid, Spain. Soft-paste porcelain. c1759.

11 Turin, Italy. Faïence. 16thC.

12 Flight & Barr, Worcester, England. 1792–1807.

13–14 Variations of Worcester Flight marks. 1702–91.

15 Bordeaux, France. 1781–87.

16 Fulper Bros, Flemington, New Jersey, USA. Impressed. 19thC.

13 *Flight*

14 *FLIGHTS*

15

16 **FULPER BROS.**
FLEMINGTON, N.J.

1 G

2 &

3 G

4 #Gx

5 &

6 a

7 G

8 a

9 G

10 Sardin

11 G D M

12 G.H.& co.

13

G

1 Bow, London, England. Porcelain. 1744–60.

2 Bow, London, England. Porcelain. 1750–70.

3–4 Tavernes, France. Faïence. 1760–80.

5 Faenza, Italy. 15thC. The town of Faenza gave its name to faïence.

6 Buen Retiro, Madrid, Spain. Soft-paste porcelain. 1759–1808.

7 Gotha, Germany. Hard-paste porcelain. Painted blue. 1775–1800.

8 Gotha, Germany. Painted blue. 1805–30.

9 Unger, Schneider, Thuringia, Germany. 1861–87.

10 Nicolas Gardin, Rouen, France. c1760.

11 Limoges, France. 1842–98.

12 Swansea, Wales. 1765–1870.

13 Emile Galle, Nancy, France. Early 20thC.

14 Guy Green, printer, Liverpool, England. 1756–99.

15 Limoges, France. c1773.

16 Alcora, Spain. Faïence/porcelain. c1750.

14 GREEN

15 GR et Cie

16 GROS

1. *h*

2. *h*

3. H

4. H.

5. H

6. HB

7. (triangle with cross, H B, and stars)

8. HDK

9. H.L.

10. h Z Z

11. HK

12. H.P.

13. HP
1636

14. HARTLEY, GREEN & C

H

1–2 Hannong, Faubourg St Lazare, Paris, France. c1773.

3 Strasburg, Germany. Faïence/porcelain. c1750.

4 Nevers, France. Faïence. 17thC.

5 D Hofdick, 'De Ster' (The Star), Delft, Holland. Faïence. c1705.

6 Antoine de la Hubaudière, Quimper, France. c1782.

7 Faincerie de la Grande Maison, Quimper, France. c1898–1902.

8 Delft, Holland. Faïence. 17thC.

9–10 Hannon & Laborde, Vincennes, France. c1765.

11 Prague, Germany. Porcelain. 1810–35.

12 Humphrey Palmer (potter), Hanley, England. c1760.

13 Winterthur, Switzerland. Faïence. 17thC.

14 Leeds, England. Pottery. c1750.

15 Hugo Booth, Stoke-on-Trent, England. c1785.

16 Henry Roudeburth, Montgomery, Pennsylvania, USA. Early 19thC.

15

H. BOOTH

16

Henry Roudeburth

April ‖ 28ᵗᴴ 1811

1. I

2. +I+ (with crosses above and below)

3. I·B

4. iB *

5. I.C.

6. I.E. 1697

7. I.W

8. IE:W:1699:
WROT:HAM

9. I.Smith

10. IRESON

11. I. & G.
RIDGWAY

12. IRONSTONE
B & M

13. I. SEYMOUR
TROY

14. I. B. FARRAR & SONS

Bow, London, England. Painted red or blue. 1744–59.

St Cloud, France. Faïence/porcelain. 1678–1766.

Bristol, England. Painted blue or gold. 1770–81.

'De Ster' (The Star), Delft, Holland. Faïence. Painted blue. c1764.

John Crolius, New York, USA. Impressed. c1790.

–8 Variations on mark from Wrotham, England. Slipware. 17th or 18thC.

Joseph Smith, Wrightstown, Pennsylvania, USA. c1775.

0 Nathaniel Ireson (potter), Wincanton, England. Tin-glazed earthenware. 1740–50.

1 Job Ridgway, Hanley, Staffordshire, England. Earthenware. 1802–8.

2 Bagshaw & Meir, Burslem, Staffordshire, England. Earthenware. Printed or impressed. 1802–8.

3 Israel Seymour, Troy, New York, USA. Impressed. c1825.

4 Isaac Farrar, Fairfax, Vermont, USA. c1800.

5 J Dale (potter), Burslem, Staffordshire, England. Late 18thC–early 19thC.

6 Lisbon, Portugal. c1773.

15

I.DALE
BURSLEM

16

IAG 9

1 **J**

2 **J**

3

4 "*F*"

5 *JR*

6 *Φ C'*

7 *F*

8 *&HS*

9 J. & W R

10 *JMF*

11 *JP.*

12 *J.F L*

13 *J.R.*

14 *R*

15 *Jw.*

Standards of pewter

The Pewterers' Company regulated the quality of the alloy, in much the same way as the Goldsmiths' Company assayed silver and gold. The three principal types of pewter are, in ascending order of quality:

- Ley pewter: 80% tin, 20% lead
- Trifle pewter: 82% or 83% tin, 17% or 18% antimony
- Plate pewter: 86% tin, 7% antimony, 3.5% copper, 3.5% bismuth

Quality marks

Ley and trifle pewter did not carry any marks of quality. Plate pewter was marked with a letter 'X' (denoting extraordinary ware), sometimes with a crown above it (**1**), or was stamped with the words 'hard metal' or 'superfine hard metal' (**2**). A rose and crown stamp (**3**) also indicated fine quality pewter. At first this mark was for export ware only, although by the 18th century it had become more generally used. From the late 17th century, the word 'London' was added to the rose and crown, but it was often used by provincial pewterers also, and so is no guarantee of provenance.

1
2
3

Touch marks

By far the most important marks on pewter are the 'touch marks' or 'touches'. These identify the maker,

and take their name from official 'touch plates' on which they were stamped when being registered at Pewterers' Hall. The earliest touch plates dated from the beginning of the 15th century but were lost in the Great Fire of London in 1666. The practice of registering marks on the touch plates began again two years later and continued until 1824.

The marks do not appear on the touch plates in chronological order, having been punched in any empty space in a haphazard fashion. Five copper touch plates survive at the Pewterers' Company, but the corresponding register of makers has been lost, making individual identification impossible in many cases.

A maker's touch mark often consisted simply of his initials or name, but could also incorporate elaborate designs, sometimes with a play on words based on the man's name. Dates also occasionally form part of the mark, but they indicate the year when the touch was registered rather than the year the piece was made.

The size of the touch marks varies according to the size of the item on which they appear, but as a very general rule, early marks tend to be smaller than later ones.

Other marks

Good early pewter often bears elaborate ownership marks in a raised form, rather like a wax seal. Triads (a triangular formation) of letters stamped on the rim of a pewter plate are generally held to give the initials of the couple who owned it.

Small marks are also found on pewter in imitation of silver hallmarks, and usually consist of four shields (**1**). The symbols in the shields generally imitate genuine silver marks quite closely – for instance, the figure of Britannia, the lion passant and the leopard's head – presumably with the purpose of persuading the buyer that the item concerned contained real silver.

After 1826, tankards and measures used in taverns had to carry capacity marks. These were of local design until 1877, after which they were validated by an excise mark consisting of a crown over the monarch's initials and a code number, denoting the area in which inspection of capacity had been carried out (**2**).

1

2

SAMPLE TOUCH MARKS

The touch marks shown on pages 164–167 are a small selection of examples where identification of the maker is possible. They are taken from Touch Plates I and IV at Pewterers' Hall, and serve to illustrate the variety that exists among the hundreds of touch marks registered there. If the touch mark you are seeking is not included, you should consult one of the specialist reference works on pewter marks in your local library.

Note that 'master', 'warden', 'steward' and 'yeoman' were ranks and appointments within the guild structure of the Pewterers' Company.

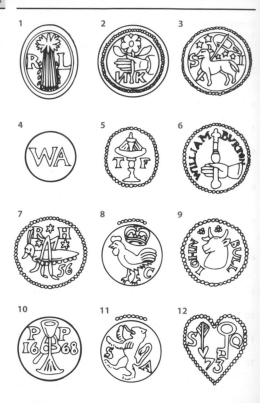

Sample marks from Touch Plates I

1 'RL' in an oval with a comet between the letters. Robert Lucas, who became a steward of the Pewterers' Company in 1651 and master in 1667.

2 'NK' in a beaded circle with a hand grasping a rose. Thought to be Nicholas Kelk, master in 1665, 1681 and 1686.

3 'SI' in a small beaded circle with a lamb and flag. Probably Samuel Jackson, working in the late 17thC.

4 'WA' in a small circle. Possibly William Austin or William Ayliffe, both working in the late 17thC.

5 'TF' in a beaded oval with a fountain. This is a pun on the maker's name, Thomas Fontaine or Fountain, who took up his livery in 1670.

6 'William Burton' in a beaded circle with a hand holding a sceptre. He was a warden in 1675 and 1680, and master in 1685.

7 'RH' in a beaded circle with a locust, three stars and the date [16]56. Ralph Hulls, warden in 1671 and 1677, master in 1682.

8 'C' in a beaded circle with a crown and cockerel. Another play on a name – Humphrey Cock, who took up his livery in 1679.

9 'John Bull' with a bull's head and two stars in a beaded circle. Late 17thC.

10 'PP' in a circle with a beacon and the date 1668. This could be the mark of Peter Parke or Peter Priest.

11 'SA' in a beaded circle with a lion rampant. Thought to be Sam Atley, who took his livery in 1667.

12 'SQ' in a beaded heart with an arrow and a key with the date [16]73. Thought to be Sam Quissenborough.

1

2

3

4

5

6

7

8

9

10

11

12

Sample marks from Touch Plates IV

1 'Henry Maxted' with pillars and the sun shining on a rose. Yeoman 1731.

2 'Iohn Kenrick' with a stork between two pillars. Yeoman 1737, warden 1754.

3 'Philip Roberts' with a lion rampant and a crescent. Yeoman 1738.

4 'RC' in a beaded circle with a lamb holding a crook. Thought to be a play on the name Robert Crooke, yeoman 1738.

5 'I Perry' with a female figure between pillars. Yeoman 1743, warden 1773.

6 'Iohn Hartwell' with a saltire and four castles. Yeoman 1736.

7 'Ionathan Leach' with a quartered shield of arms showing a rose, a sprig of laurel and a lamb and flag. The fourth quarter is illegible. Yeoman 1732.

8 'Thomas Giffin' with a dagger piercing a heart and a ducal coronet, all between pillars. Yeoman 1759.

9 'A Jenner' in a plain rectangle. Thought to be Anthony Jenner, yeoman 1754.

10 'Ino Appleton' with a still and a worm. Yeoman 1768, warden 1799, master 1800.

11 'C Swift' in an indented square with a thistle and a rose (the badge of Queen Anne). Yeoman 1770.

12 'Wood & Hill' with two sheep in a shield. Thought to be Thomas Wood (yeoman 1792) and Roger Hill (yeoman 1791).

Note: 'I' was often used for 'J'. 'Ino' and 'Jno' stand for 'John'.

4. POTTERY AND PORCELAIN

Unlike the strictly regulated hallmarks which appear on precious metals – and which give today's collector a foolproof means of identification – the marks that appear on pottery and porcelain are a far from reliable guide as to provenance.

Marks may be blurred and impossible to identify. A particular mark – say, an anchor – can indicate a wide variety of periods, factories and countries, and a true attribution can be given only by looking at the weight, colour, shape and pattern of the piece itself. The size and colour of the mark, as well as the way it was made, also have a bearing on its identification. Often marks have been used which imitated those of famous factories – for example, there were endless copies of the Meissen crossed swords. Marks have also been added fraudulently at later dates.

If a piece of pottery bears no mark at all, it does not mean the piece is necessarily of an early date, because much pottery from every period bears no mark at all. Confusion may also result from the fact that a mark may refer to a factory, to a potter or painter who worked there, or to a past owner of the piece. Dates, too, are not to be taken at face value, because they rarely give the date of actual manufacture. When incorporated into a mark, a date commonly indicates the year when the factory was established, or when a particular design was introduced. However, the design registration marks which were applied from 1842 do give reliable dates for British wares thereafter. There

were also a few factories which employed their own reliable dating systems, notably Sèvres, Derby, Minton and Wedgwood.

Pottery and porcelain are best understood by looking and touching, and the more you see and handle the various wares, the more of a feel you will get for them. Once you are more confident in your knowledge of the wares themselves, marks can be used as a very useful back-up. Nevertheless, approaching marks with a good deal of healthy suspicion is always to be recommended!

Pottery types

Pottery is made simply of clay, but many additions have been made to the clay mix to give added strength, and decorative glazes have been applied to enhance appearance. The following types are among the most common and important:

- **Creamware:** earthenware with a cream-coloured glaze, giving something of the impression of porcelain.
- **Delft:** Earthenware with a tin glaze, made in the 17th and 18th centuries.
- **Faïence:** Tin-glazed earthenware.
- **Majolica:** Decorative tin-glazed earthenware first made in 15th-century Italy and copied in the 19th century.
- **Stoneware:** A strong non-porous ware made from adding sand or flint to the clay.
- **Ironstone:** Patented by Charles James Mason in 1813, using slag from iron furnaces to strengthen the wares.

Porcelain types

Porcelain was first made in China from the vital ingredients of kaolin (China clay) mixed with petuntse (China rock). It is recognised by its strength, its musical note when struck, and its translucent delicacy.

From the moment porcelain was first imported in the 15th century, it was a huge success in Europe and there were many attempts made to reproduce it in the West. The ingredients for the hard paste porcelain of the Chinese original were eventually found at Meissen in what is now Germany, and porcelain production began there in the early 18th century. The process was then imitated throughout Europe.

Other experiments to imitate porcelain produced soft-paste porcelain, which has a less hard, glittery glaze than hard-paste porcelain, as well as less strength.

METHODS OF APPLYING MARKS

The way in which a mark is made can help in attributing it to a particular factory (as can its colour). Where relevant, this has been noted in the pages which follow. There are four main methods:

- **Incising:** This is one of the earliest and simplest methods, whereby a mark is scratched into the clay before it is fired.

- **Impressing:** A stamp is used to press a mark into the unfired clay.

- **Underglaze painting or transfer-printing:** Until 1850 this appeared only in blue, after which other colours were used. As the name suggests, the mark was made before the final glaze was applied over it.

- **Overglaze marks:** These may be painted, transfer-printed or stencilled onto finished wares. This method is a particularly easy one for forgers to imitate.

A THUMBNAIL GUIDE TO ESTABLISHING DATES

- A printed mark signifies post-1800 manufacture
- Marks which include the royal arms appeared only after 1810
- Marks including the name of a pattern are also post-1810, and often much later
- The diamond registration mark indicates the period 1842–83 (*see page 172*)
- 'Limited' or 'Ltd' denotes 1860 onwards
- 'Trade mark' signifes 1862 onwards
- The practice of using 'Royal' followed by the manufacturer's name began in the mid-19th century
- 'Rd No' (Registered Number) was introduced in 1884
- The word 'England' was used from 1891 and 'Made in England' from early in the 20th century

REGISTERED DESIGN MARKS

The system of Registered Designs was devised in 1839 to protect the design of industrial products in much the same way that the patent laws protect inventions. There were two early layouts of Registered Design Marks, one in use from 1842 to 1867, the other from 1868 to 1883.

Mark layout 1842–67

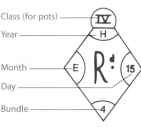

Class (for pots)
Year
Month
Day
Bundle

Year codes 1842–67	
A 1845	N 1864
B 1858	O 1862
C 1844	P 1851
D 1852	Q 1866
E 1855	R 1861
F 1847	S 1849
G 1863	T 1867
H 1843	U 1848
I 1846	V 1850
J 1854	W 1865
K 1857	X 1842
L 1856	Y 1853
M 1859	Z 1860

Mark layout 1868–83

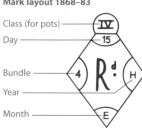

Class (for pots)
Day
Bundle
Year
Month

Year codes 1868–83	
A 1871	K 1883
C 1870	L 1882
D 1878	P 1877
E 1881	S 1875
F 1873	U 1874
H 1869	V 1876
I 1872	X 1868
J 1880	Y 1879

Month codes 1842–83

The same system of code letters was used to indicate the month of registration on both types of design mark layout shown opposite.

A	December	E	May	K	November
B	October	G	February	M	June
C/O	January	H	April	R	August
D	September	I	July	W	March

REGISTRATION NUMBERS

From 1884, the complex diamond-shaped registration mark was replaced by a simple registration numbering system. The abbreviation 'Rd No' (for Registered Number) often appeared before the number. The system remains in use today. The dates of numbers used in the early years are given in the table below.

Rd No	Year	Rd No	Year
1	1884	291241	1897
19754	1885	311658	1898
40480	1886	331707	1899
64520	1887	351202	1900
90483	1888	368154	1901
116648	1889	385088	1902
141273	1890	402913	1903
163767	1891	425017	1904
185713	1892	447548	1905
205240	1893	471486	1906
224720	1894	493487	1907
246975	1895	518415	1908
268392	1896	534963	1909

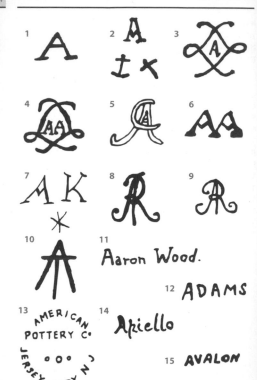

1. A

2. A t x

3. A

4. AA

5. CA

6. AA

7. A K *

8. R

9. R

10. A

11. Aaron Wood.

12. ADAMS

13. AMERICAN POTTERY C° JERSEY CITY N J ° ° °

14. Apiello

15. AVALON

A

1 Paris, France. Painted red/gold. c1795.
2 Bow, London, England. Red. c1765.
3 Sèvres, France. Mark and date letter for 1753. Date letters ran alphabetically until 1793 (AA from 1778) appearing inside or alongside the 'crossed l s' in blue (or later red) enamel.
4 Sèvres, France, 1778.
5 Nymphenberg, Germany. Impressed or incised. c1745.
6 Arras, France. Soft-paste porcelain. 1770–90.
7 'De Ster' (The Star), artist A Kiell. Delft, Holland. c1763.
8 Helene Wolfsohn, decorator. Meissen, Germany. c1860.
9 Meissen, Germany. Painted underglaze blue. c1725.
10 Thomas Allen (painter). Wedgwood. 1875–1905.
11 Burslem, Staffordshire, England. Impressed. c1750.
12 Adams & Co, Tunstall, England. From c1790.
13 New Jersey, USA. Printed. Mid-19thC.
14 Capo-di-Monte, Italy. Incised. c1760.
15 Cartwright Bros, East Liverpool, Ohio, USA. 1880–1900.

2

B

1

BARR FLIGHT & BARR.
Royal Porcelain Works.
WORCESTER.

London-House.
Nº 1 Coventry Street.

3

4

+
B

5

B

6

7

B & G

8

. B . H .

9

B L

10

11

B.S. & T.

12 BELPER POTTERY
DENBY

14 *Booth*

13 *6 Compot*

15 *Bristoll*

B

1 Flight & Barr, Worcester, England. Scratched in clay. 1793–1800. The most common Worcester marks are crescents, the letter W and copies of Chinese and Meissen marks.

2 Worcester. Printed. 1807–13. Later Worcester wares carry the full name.

3 Lille, France. Faïence. 1720–88.

4 Bristol, England. Painted. c1773.

5 Sèvres, France. 1754.

6 Bristol, England. 1773.

7 Bing & Grondahl, Copenhagen, Denmark. 1853.

8 Knoller, Bayreuth, Germany. Faïence. c1730.

9 Limbach, Germany. Porcelain. Late 18thC.

10 Niderviller, France. 1744–80.

11 Barker, Sutton & Till, Burslem, Staffordshire, England. 1830–50.

12 Belper Pottery, Derbyshire, England. Stoneware. 1812.

13 'De Vergulde Bloompot' (The Golden Flowerpot), Delft, Holland. c1693.

14 Enoch Booth, Tunstall, Staffordshire, England. Impressed. c1750.

15 Bristol, England. Porcelain. c1750.

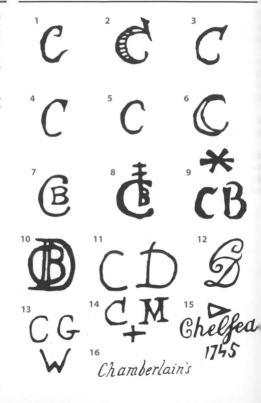

1 2 3

4 5 6

7 8 9

10 11 12

13 14 15 *Chelfea* 1745

16 *Chamberlain's*

Nantes, France. c1780.

-6 Caughley, England. Variations of the Caughley mark, printed or painted in underglaze blue 1772–95.

Bayreuth, Germany. Painted. 1744.

Castel-Durante, Italy. c1570.

'De Ster' (The Star), C D Berg, Delft, Holland. c1720.

0 Coalport, Coalbrookdale, England. Hard-paste porcelain. Painted blue. c1825–50.

1 Limoges, France. Hard-paste porcelain. c1783.

2 Coalport, Coalbrookdale, England. Hard-paste porcelain. Painted blue. Early 19thC.

3 Leeds, England. c1760.

4 St Cloud, France. Faïence/porcelain. c1711.

5 Chelsea, London, England. Soft-paste porcelain. c1745.

6 Worcester, England. Red. 1788–1808.

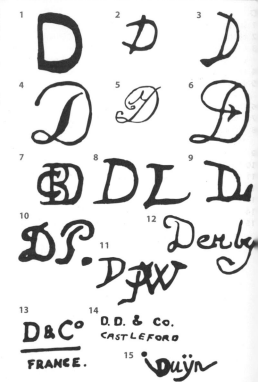

1 D 2 D 3 D
4 D 5 D 6 D
7 D 8 DL 9 D
10 D.P. 12 Derby
11 DAW
13 D&C° 14 D.D. & Co.
CASTLEFORD
FRANCE. 15 Duÿn

D

1 Davenport, England. Impressed. 1793–1882.

2 Derby, England. 1770–84.

3 Caughley, England. Hard-paste porcelain. Painted blue. c1750.

4 Derby, England. Soft-paste porcelain. Red. c1756.

5 John Donaldson (painter), Worcester, England. Porcelain. c1770.

6 Derby (Chelsea), England. c1782.

7 Coalport, Coalbrookdale, England. Painted blue. c1825–50.

8 William Littler, potter, Longton Hall, Staffordshire, England. 1750–60.

9 Louis Dorez, Nord, France. c1735.

10 Proskau, Silesia, Germany. Faïence. 1770–83.

11 'De Paauw' (The Peacock), Delft, Holland. Faïence. c1700.

12 Derby, England. Incised. c1750.

13 Limoges, France. c1875.

14 Castleford, England. Pottery. Impressed. c1790.

15 J van Duyn, 'De Porceleyne Schootel' (The Porcelain Dish), Delft, Holland. Faïence. Painted blue. c1764.

1 \mathcal{E}

2 \mathcal{E}

3 \mathcal{E}
1779

4 **EB**

5 \mathcal{Ef}

6 E. I. B

7 E · L
1754

8 E
M+B
J760

9 E.Borne
1689

10 ENGLAND

11 ENOCH BOOTH
1757

12 Enoch Wood

13 E. NORTON
BENNINGTON
VT.

14 $\mathcal{F} \mathcal{T}$

15 E ⋈ J

Elton Pottery, Somerset, England. 1880–90.

St Petersburg, Russia. 1762–96.

Derby, England. 1779.

Paris, France. c1800.

Moustiers, France. Faïence. 18thC.

Hanley, England. Impressed. 18thC.

Bow, London, England. c1754

Michael Edkins and his wife, Bristol, England. Blue. c1760.

Henri Borne, Nevers, France. c1689.

0 From 1891, the word 'England' appeared on English wares.

1 Tunstall, Staffordshire, England. c1757.

2 Burslem, England. Impressed, moulded or incised. 1784–90.

3 Bennington, Vermont, USA. Impressed. c1882.

4 Ernst Teichert, Meissen, Germany. Late 19thC.

5 E Jacquemin, Fontainebleau, France. 1862–66.

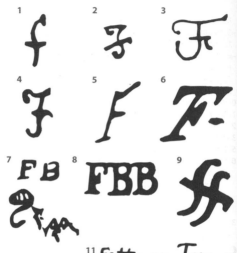

11 Fatto en Torino

12 Flight & Barr
Worcester
Manufacturers to their
Majesties

1 G

2 g

3 G

4 $\#G^x$

5 G

6 G

7 G

8 G

9 G

10 Sardin

11 G D M

12 G.H.& co.

13

G

1 Bow, London, England. Porcelain. 1744–60.

2 Bow, London, England. Porcelain. 1750–70.

3–4 Tavernes, France. Faïence. 1760–80.

5 Faenza, Italy. 15thC. The town of Faenza gave its name to faïence.

6 Buen Retiro, Madrid, Spain. Soft-paste porcelain. 1759–1808.

7 Gotha, Germany. Hard-paste porcelain. Painted blue. 1775–1800.

8 Gotha, Germany. Painted blue. 1805–30.

9 Unger, Schneider, Thuringia, Germany. 1861–87.

10 Nicolas Gardin, Rouen, France. c1760.

11 Limoges, France. 1842–98.

12 Swansea, Wales. 1765–1870.

13 Emile Galle, Nancy, France. Early 20thC.

14 Guy Green, printer, Liverpool, England. 1756–99.

15 Limoges, France. c1773.

16 Alcora, Spain. Faïence/porcelain. c1750.

14 **GREEN**

15 *GR et Cie*

16 **GROS**

1

2

3

4

5

6

7

8

9

10

11

12 **H.P.**

13 *HP*
1636

14 **HARTLEY, GREEN & c**

–2 Hannong, Faubourg St Lazare, Paris, France. c1773.
Strasburg, Germany. Faïence/porcelain. c1750.
Nevers, France. Faïence. 17thC.
D Hofdick, 'De Ster' (The Star), Delft, Holland. Faience.
c1705.
Antoine de la Hubaudière, Quimper, France. c1782.
Faincerie de la Grande Maison, Quimper, France.
c1898–1902.
Delft, Holland. Faïence. 17thC.
–10 Hannon & Laborde, Vincennes, France. c1765.
1 Prague, Germany. Porcelain. 1810–35.
2 Humphrey Palmer (potter), Hanley, England. c1760.
3 Winterthur, Switzerland. Faïence. 17thC.
4 Leeds, England. Pottery. c1750.
5 Hugo Booth, Stoke-on-Trent, England. c1785.
6 Henry Roudeburth, Montgomery, Pennsylvania, USA.
Early 19thC.

15

H. BOOTH

Henry Roudeburth

16 April 28th 1811

1 I

2 +I+ (with crosses above and below)

3 I·B

4 iB *

5 I. C.

6 I.E. 1697

7 I. W

8 IE:W:1699:
 WROT:HAM

9 I. Smith

10 IRESON

11 I. & G.
 RIDGWAY

12 IRONSTONE
 B & M

13 I. SEYMOUR
 TROY

14 I. B. FARRAR & SONS

Bow, London, England. Painted red or blue. 1744–59.

St Cloud, France. Faïence/porcelain. 1678–1766.

Bristol, England. Painted blue or gold. 1770–81.

'De Ster' (The Star), Delft, Holland. Faience. Painted blue.
c1764.

John Crolius, New York, USA. Impressed. c1790.

–8 Variations on mark from Wrotham, England. Slipware.
17th or 18thC.

Joseph Smith, Wrightstown, Pennsylvania, USA. c1775.

0 Nathaniel Ireson (potter), Wincanton, England. Tin-glazed
earthenware. 1740–50.

1 Job Ridgway, Hanley, Staffordshire, England. Earthenware.
1802–8.

2 Bagshaw & Meir, Burslem, Staffordshire, England.
Earthenware. Printed or impressed. 1802–8.

3 Israel Seymour, Troy, New York, USA. Impressed. c1825.

4 Isaac Farrar, Fairfax, Vermont, USA. c1800.

5 J Dale (potter), Burslem, Staffordshire, England. Late
18thC–early 19thC.

6 Lisbon, Portugal. c1773.

15

I.DALE
BURSLEM

16

IAG 9

1 **J**

2 **J**

3 *(Star of David containing)* **J 1777**

4 " **J** "

5 **JA**

6 **ФC·**

7 **J**

8 **&JHS**

9 **J. & W R**

10 **JMF**

11 **JP·**

12 **J. P L**

13 **J. R.**

14 **R**

15 **Jwe**

J

1 Longton Hall, Newcastle, England. Porcelain/stoneware. 1750–60.

2 Ilmenau, Thuringia, Germany. Faïence/porcelain. c1777.

3 Ilmenau, Thuringia, Germany. 1900–40.

4 Copenhagen, Denmark. 1750–60.

5 Aprey, France. Faïence. c1750.

6 J Dimmock & Co, Hanley, Staffordshire, England. Late 19thC.

7 G Jones & Sons, Stoke-on-Trent, England. Late 19thC.–early 20thC.

8 James Hadley & Sons, Worcester, England. 1896–1903.

9 Bell Works, Shelton, England. Pottery. Printed. 1770–1854.

10 St Cloud, France. Soft-paste porcelain. 1678–1766.

11 Jacob Petit (potter), Fontainebleau, France. Hard-paste porcelain. Painted blue. c1800.

12 Jean Pouyat (potter), Limoges, France. Painted red. 1842.

13 John Remney, New York, USA. Stoneware. c1775.

14 Joseph Robert (potter), Marseilles, France. Porcelain. 1754–93.

15 Ashby Potters Guild, Burton-on-Trent, England. Pottery. Early 20thC.

1. K
2. K
3. K
4. K
5. K.H. / P.A
6. K.H.C.W
7. K.P.M
8. K.P.M.
9. Keeling Toft & Co.
10. K & G LUNEVILLE
11. KIEBZ 13 II
12. Kishere
13. KLUM

K

1 Klosterle, Bohemia, Germany. Porcelain, lead-glazed earthenware. 1794–1803.

2 Jan Kuylich, Delft, Holland. Faïence. Painted blue. 17thC.

3 Jan Kuylich the younger, Delft, Holland. Faïence. Painted blue. Registered 1680.

4 Kiel, Germany. Faïence. c1770.

5 Meissen, Germany. Hard-paste porcelain. 1720–60.

6 Königliche Hof Conditorei, Meissen, Germany. Hard-paste porcelain. Painted blue. 1720–60.

7 Königliche Porzellan Manufaktr, Meissen, Germany. Hard-paste porcelain. Underglaze blue. c1723.

8 Krister, Germany. 19thC.

9 Keeling (potter), Hanley, Staffordshire, England. Impressed. 1806–24.

10 Keller & Guerin (owners), Lunéville, France. Faïence. 1778.

11 Kiev, Russia. Porcelain. 1798–1850. Stoneware. 1800–11.

12 Joseph Kishere (potter), Mortlake, England.

13 Klum, Germany. Porcelain. 1800–50.

14 Smith-Phillips China Co, East Liverpool, Ohio, USA. Late 19thC.

15 Knowles, Taylor & Knowles, East Liverpool, Ohio, USA. Established 1854.

14 **KOSMO**

15 **K.T. & K.
CHINA**

1 2 3 4
5 6 7
8 9 10
11 LEEDS POTTERY
12 LEEDS · POTTERY
LEEDS · POTTERY

L

1–3 Jean-Joseph Lassia (proprietor), Paris, France. Porcelain. 1774–84.

4 Lille, France. Hard-paste porcelain. Late 18thC.

5 Tours, France. Faïence. c1756.

6 Valenciennes, Nord, France. Faïence. 1735–80.

7 Limbach, Thuringia, Germany. Hard-paste porcelain. Painted red. c1772.

8 Buen Retiro, Spain. Soft-paste porcelain. 1759–66.

9 Valenciennes, Nord, France. Faïence, hard-paste porcelain. c1785.

10 St Cloud, France. Faïence, porcelain. 1678–1766.

11–13 Leeds, England. Creamware. Late 18thC.

14–16 Limbach, Thuringia, Germany. Late 18thC.

13

LEEDS ✳ POTTERY

14

15

16

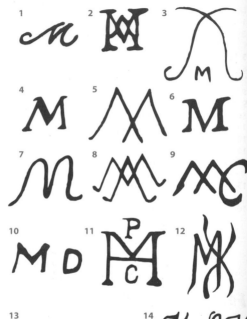

13

MASON'S PATENT
IRONSTONE CHINA

M

1–2 Rouen, France. 1720–30.

3–4 Minton, Stoke-on-Trent, England. Underglaze blue. 1800–30.

5 Longton Hall, Newcastle, Staffordshire, England. 1750–60.

6–7 Pierre Roussencq (founder), Marans, France. Faïence. Late 18thC.

8 Moreau Ainé, Limoges, France. Late 19thC.

9 Arnoldi, Germany. Early 19thC.

10 Mennecy, France. Porcelain. 1734–73.

11 Herculaneum, Liverpool, England. 1833–41.

12 Schmidt Brothers, Germany. Late 18thC.

13 Mason, Fenton, England. Faïence. Printed. 1813.

14 Meissner Porzellan Manufaktur, Dresden, Germany. Hard-paste porcelain. c1723.

15 Minton & Boyle, Stoke-on-Trent, England. Impressed. 1836–41.

16 Mayer & Newbold (potters), Hanley, England. Early 19thC.

¹⁵ **M&B**

FELSPAR PORCELAIN

¹⁶ **M. & N.**

1 \mathcal{N} 2 \mathcal{N} 3 N

4 N 5 N° 6 \mathcal{U}_+

8 × 5 \mathcal{N} 9 ⋈

7 N.A

10 N&R 11 Nantgarw

12 NEWCASTLE

13 New Hall 14 NOTTN 1703

N

1 Niderviller, France. Faïence. Mid- to late 18thC.

2 Derby, England. Incised blue or red. c1770.

3 New Hall, Shelton, England. Painted red. 1782–1810.

4 New Hall, Shelton, England. Painted black. 1782–1810.

5 Nove, Venice, Italy. 1800–25.

6 Limbach, Germany. Porcelain. Late 18thC.

7 Wrotham, England. 17thC.

8 Bristol, England. Pottery, porcelain. Overglaze blue or gold. 18thC.

9 Urbino, Italy. Pottery. 16thC.

10 Christian Nonne & Roesch (owners), Ilmenau, Thuringia, Germany. Porcelain. c1786.

11 Nantgarw, Wales. Hard-paste porcelain. Painted red. c1811.

12 Newcastle-upon-Tyne, England. Pottery. Impressed. c1800.

13 New Hall, Shelton, England. Painted red. Late 18thC.

14 Nottingham, England. Pottery. c1705.

15 Niderviller, France. Faïence. Mid- to late 18thC.

16 Bassano, Italy. Soft-paste porcelain. c1760.

1 O 2 G 3 oB 4 oP.

5 OS 6 7 O.V.

8 ·OY. 10 OLDFIELD & CO

9 O.&B.

11 OLIVER
A PARIS 12 OPAQUE CHINA

13 Opaque China

B.B.&I.

14 ORIENTAL 15 ()rlean
STONE 16 OWENS
J.&G.ALCOCK UTOPIAN

O

1 Bow, London, England. Porcelain. c1750.

2 St Petersburg, Russia. Porcelain. c1760.

3 Mennecy-Villeroy, France. Porcelain, faïence. Mid-18thC.

4 Mennecy-Villeroy, France. Porcelain, faïence. Painted blue. c1773.

5 George Oswald (painter and potter), Ansbach, Bavaria, Germany. 1692–1733.

6 Oscar Schlegelmilch, Thuringia, Germany. Late 19thC.

7 Ohio Valley China Co, Wheeling, West Virginia, USA. c1890.

8 Olerys & Laugier (managers), Moustiers, France. Hard- and soft-paste porcelain. c1739.

9 Ott & Brewer, Trenton, New Jersey, USA. c1880.

10 Brampton, England. Brownware. c1825.

11 Olivier (potter), Paris, France. Faïence. Late 18thC.

12 Cambrian, Wales. Earthenware. c1807.

13 Baker, Bevans & Irwin, Swansea, Wales. c1830.

14 J & G Alcock, Cobridge, England. Mid- to late 19thC.

15 Duke of Orleans (patron), Loiret, France. Mid-18thC.

16 J B Owens Pottery Co, Zanesville, Ohio, USA. c1890.

15. P. P. Coy. L.
Stone China

16. poupre
d japonn

P

1–2 Seth Pennington (potter), Liverpool, England. Painted gold or colour. Late 18thC.

3–4 James & John Pennington (potters and painters), Liverpool, England. Painted gold or colour. Mid-18thC.

5–6 Pinxton, Derbyshire, England. Soft-paste porcelain. 1796–1813.

7 St Cloud, France. Faïence, porcelain. Mid-18thC.

8 Nymphenberg, Germany. Porcelain. Impressed or incised. Mid-18thC.

9 Philippe-Auguste Petit (potter), Lille, France. Painted colour. c1778.

10 Pigory (owner), Chantilly, France. Soft-paste porcelain. Early 19thC.

11 Rouen, France. Faïence. Painted colour. 16th or 17thC.

12 Moustiers, France. Faïence. Mid-18thC.

13 Paul Hannong (proprietor), Strasburg, France. Underglaze blue. 1740–60.

14 Paris, France. 1786–1793.

15 Plymouth Pottery Co, Plymouth, England. c1850.

16 Moulins, France. Faïence. c1730.

1 R
2 R
3 R
4 R
5 ℞
6 R *
7 R *
8 R
9 RB
10 R
11 R
12 RAINFORTH & CO.
13 Rockingham
14 R Hancock fecit

R

1 Louis-François Roubiliac (sculptor), Chelsea, London. Impressed. c1738.

2 Bristol, England. Porcelain. c1750.

3 Marseilles, France. Porcelain. 1773–93.

4 Bow, London, England. Porcelain. 1750–60.

5 Joseph Gaspard Robert (potter), Marseilles, France. Faïence. 1754–93.

6–7 Rauenstein, Thuringia, Germany. Porcelain. 1783.

8 Rouen, France. 16th–17thC.

9 Bow, London, England. Porcelain. 1750–60.

10 Sèvres, France. Hard- and soft-paste porcelain. Painted blue, gold. 1793–1804.

11 Meissen, Germany. Hard-paste porcelain. Underglaze blue c1730.

12 Rainforth (potter), Leeds, England. Late 18th or early 19thC.

13 Rockingham, Swinton, Yorkshire, England. Late 18th or early 19thC.

14 Worcester, England. Hard-paste porcelain. 1756–1774. 'Made by R Hancock'

15 William Reid (potter), Liverpool, England. Porcelain. Impressed. 1755–59.

16 Ralph Toft (potter), Wrotham, England. Slipware. c1677.

15 **Reid & Co.**

16 **RALPH TOFT**

1. ⊤⊤

2. S

3. S

4. S

5. ·S· +

6. (symbol)

7. ſ.

8. J⋅F
S
1750

9. SX

10. Sx

11. Sₓ

12. S.A. & CO.

13. Sadler

14. **SALOPIAN**

15. SPODE.

16. SPODE & COPELAND

S

1 St Petersburg, Russia. Hard-paste porcelain. Painted blue. c1744.

2–3 Caughley, England. Hard-paste porcelain. Painted blue. 1755–99.

4 Rouen, France. Faïence. c1760.

5 St Cloud, France. Faïence, porcelain. 1678–1766.

6 Eisenach, Germany. Mid- to late 19thC.

7 Schlaggenwald, Bohemia, Germany. Porcelain. 1793–1866.

8 Joseph Flower (painter), Bristol, England. Delft. 1739–51.

9–10 Jacques Chapelle (potter), Penthièvre factory, Sceaux, Seine, France. Soft-paste porcelain. 1749–63. Later 'Sceaux' painted in blue.

11 Caughley, England. Porcelain. 1750–1814.

12 Smith, Ambrose & Co, Burslem, Staffordshire, England. c1800.

13 John Sadler (engraver), Liverpool, England. Pottery and hard paste porcelain. Printed. 1756–70.

14 Caughley, England. Porcelain. Impressed. 1750–1814. Caughley factory taken over in 1799 by Coalport.

15 Spode. Stoke-on-Trent, England. Porcelain. Impressed. Painted red, blue, black or gold. c1770.

16 Spode & Copeland, Stoke-on-Trent, England. 1770–97.

1 2 3 4

5 6 7

8 9 *Tannova*

10 **T. FELL & CO.**

11 **T. FLETCHER & CO.**

ThoMA

12 ToFT

13 *Théodore Haviland*

Limoges

FRANCE

T

1–3 Thomas Frye (manager), Bow, London. Porcelain.
1744–59.

4 Tebo (modeller), Bristol, England. Porcelain. 1770–75.

5 Tite Ristori, Nevers, France. Pottery. c1850.

6 Torquay, Devon, England. Terracotta. 1875–1909.

7 Nevers, France. Faïence. 18thC.

8 T Vickers, Lionville, Pennsylvania, USA. c1805.

9 Tannowa, Bohemia, Germany. Faïence, porcelain. 1813–80.

10 Thomas Fell (potter), Newcastle, England. c1817.

11 T Fletcher (owner), Shelton, England. 18thC.

12 Thomas Toft (potter), Burslem, England. Slipware. c1670.

13 Theodore Haviland, Limoges, France. c1920.

14 Theodore Haviland, New York, USA. Printed green or
black. c1936.

15 Warne & Letts, South Amboy, New Jersey, USA. c1806.

16 Theodore Deck, Paris, France. Faïence. c1859.

14

THEODORE HAVILAND
NEW YORK

15 **T.W.J.L.**

16 **TD**

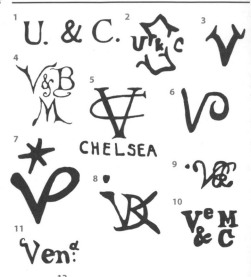

1 U. & C.
2 U r k c
3 V
4 V & B M
5 V
6 V
7 ★ V
CHELSEA
8 V R
9 VE
10 V^e M & C
11 Ven^d
12 VILLEROY & BOCH
13 Velazg^z
14 VC

U, V

1 J Uffrecht, Haldensleben, Germany. Late 19thC.

2 Sarreguemines, France. Faïence, porcelain, c1770.

3 Nathaniel Hewelcke (potter), Venice, Italy. Porcelain.
 Incised. 1757–63.

4 Villeroy & Boch, Mettlach, Saar, Germany. 1890–1910.

5 Charles Vyse, Chelsea, London. Early 20thC.

6–7 Veuve Perrin (potter), Marseilles, France. Faïence. Painted
 black. c1790.

8 Jan van der Kloot, Delft, Holland. Faïence. Painted blue.
 c1765.

9 Baron Jean-Louis Beyerle, Niderviller, France. Faïence.
 1754–70.

10 Rue Thiroux factory, Paris, France. Hard-paste porcelain.
 c1775.

11 Venice, Italy. Hard-paste porcelain. c1700.

12 Villeroy & Bosch (potters), Mettlach, Germany. Faïence.
 c1842.

13 Buen Retiro, Spain. Hard-paste porcelain. 1759–1808.

14 Alcora, Spain. Porcelain, faïence. Mid-18thC.

15 Varages, France. Faïence. 18thC.

16 Vinovo, Italy. Porcelain. Underglaze blue or incised. c1775.

15

16

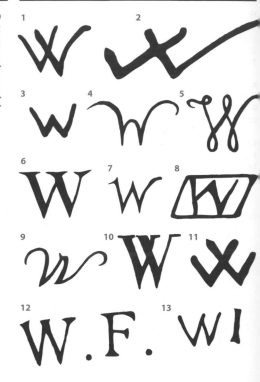

W

1 Plymouth, England. Hard-paste porcelain. Painted blue. c1768.

2 Plymouth, England. Painted red, blue, gold. c1768.

3 Thomas Wolfe (potter), Stoke-on-Trent, England. Impressed. 18th–19thC.

4–8 Variations of the Worcester mark. Hard-paste porcelain. 1775–83.

9 Rouen, France. Faïence. c1720.

10–11 Wegeley (founder), Berlin, Germany. Porcelain. 1751–60.

12 Bristol, England. c1853.

13 Chelsea, London, England. Porcelain. 1745–84.

14–15 Variations of the Worcester mark. Late 18thC.

16 Absolon (enameller), Yarmouth, England. c1800.

1. *Walton*

2. W. & B.

3. Wedgwood

4. WEDGWOOD

5. WEDGWOOD & CO

6. Wedgwood & Co.
 Ferrybridge

7. WEDGWOOD
 ENGLAND

8. Z WEDGWOOD WW

9. WINCANTON

10. XX

11. XX

12. XE

13. Z

14. Z

W, X, Y, Z

1 John Walton (potter), Burslem, England. Earthenware. 18th–19thC.

2 Wedgwood & Bentley, Staffordshire, England. Earthenware. 1769–80.

3 Wedgwood, Etruria, England. Pottery. Impressed. c1771.

4 Wedgwood, Etruria, England. Impressed on pottery, 1771. Printed red, blue, gold on porcelain, 1812–16.

5–6 Ralph Wedgwood, Ferrybridge, England. Stoneware. Impressed. 1796–1800.

7 Wedgwood. Pottery. After 1891.

8 Wedgwood. Pottery. Impressed. After 1780.

9 Wincanton, Bristol, England. Earthenware. 17thC.

10–11 Vaux (or Bordeaux), France. Hard-paste porcelain. Late 18thC.

12 'De Griekse A' (The Greek A), Delft, Holland. c1674.

13–15 Zurich, Switzerland. Pottery, hard-paste porcelain. Painted blue. Late 18thC.

16 Worcester. 1775–85.

15

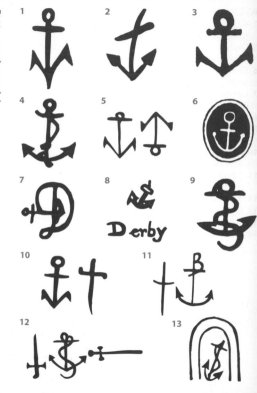

ANCHORS

1–4 Chelsea, London, England. Porcelain. Underglaze blue, gold. 1750–69.

5 Chelsea, London, England. Soft paste porcelain. Painted gold or red. c1745.

6 Chelsea, London, England. Soft-paste porcelain. Underglaze blue or red, blue, purple. 1749–56.

7 Derby-Chelsea, England. Porcelain. Painted blue, lilac or gold. c1770.

8 Derby, England. Porcelain. c1745.

9 Bow, London, England. Hard-paste porcelain. Painted red or blue. c1744.

10 Bow, London, England. Soft-paste porcelain. Painted red or brown. c1760–80.

11–12 Bow, London, England. Soft-paste porcelain. Painted red, brown or blue. c1760–80.

13 Bow, London, England. Porcelain. 1745–70.

14 Liverpool, England. Cream earthenware. 1793–1841.

15 Sceaux factory, Seine, France. Porcelain, faïence. c1775.

16 Thomas Fell (potter), Newcastle, England. Impressed. 18th–19thC.

14

15

16

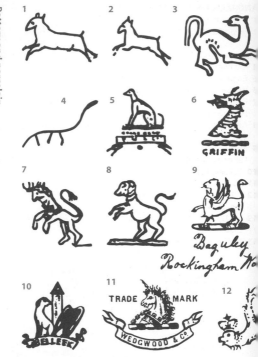

1

2

3

4

5

6
GRIFFIN

7

8

9
Baguley
Rockingham Wo

10
BELEEK

11
TRADE MARK
WEDGWOOD & CO.

12

ANIMALS, FISHES AND INSECTS

1 Furstenberg, Germany. Porcelain. 18thC.

2 Hesse Cassel, Germany. Hard-paste porcelain. Painted blue. c1763.

3 Oiron, France. 16thC.

4 'De Klauw' (The Claw), Delft, Holland. Mid-18thC.

5 Edgem Malkin, Burslem, England. Late 19thC.

6 Williamson, Longton, England. Early 20thC.

7 Frankenthal, Bavaria, Germany. Hard-paste porcelain. Painted blue. c1754.

8 Amsterdam, Holland. Hard-paste porcelain. Painted blue. c1772.

9 Rockingham, Swinton, England. Hard-paste porcelain. Painted red. c1824.

10 Belleek, Ireland. c1860.

11 Ralph Wedgwood, Burslem, England. 1796–1800.

12 Lille, France. Hard-paste porcelain. Stencilled and painted red. c1784.

13–14 Nyon, Switzerland. Hard-paste porcelain. Underglaze blue. c1780.

15 Seville, Spain. Glazed pottery. 19thC.

13

14

15

ARROWS

1–5 Bow, London, England. Porcelain. c1750.

5 Plymouth, England. Hard-paste porcelain. Painted blue. 1768–70.

7–8 Leeds, England. Pottery. Impressed. c1774.

9–11 Caughley. England. Hard-paste porcelain. Painted blue. Mid–late 18thC.

12 Derby, England. Porcelain. c1830.

13 Derby, England. Porcelain. 1745–1848.

14 Robert Allen (painter), Lowestoft, England. Porcelain. 1757–80.

15 W Absolon (enameller), Yarmouth, England. Porcelain, earthenware. Impressed. Early 19thC.

16 Rue de la Roquette factory, Paris, France. Hard-paste porcelain. Painted blue. c1774.

17 La Courtille factory, Paris, France. Hard-paste factory. Underglaze blue, incised. c1771.

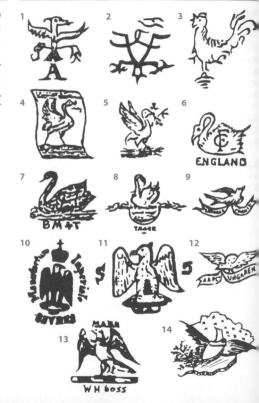

1

2

3

4

5

6

ENGLAND

7

BM&T

8

TABOR

9

10

Imperial
Bayern

11

S

S

12

AAPC UNGARN

13

MARK

14

WH boss

BIRDS

1–2 Ansbach, Bavaria, Germany. Hard-paste porcelain. Painted blue. c1765.

3 J V Kerckof (artist), Amsterdam, Holland. 1755–70.

4–5 Herculaneum factory, Liverpool, England. c1833.

6 Charles Ford, Burslem, England. 19thC.

7 Doulton, Machin & Tennant, Tunstall, England. Late 19thC.

8 T Rathbone, Tunstall, England. Early 20thC.

9 Limoges, France. 1842–98.

10 Sèvres, France. Hard-paste porcelain. Painted red. c1810.

11 Sèvres, France. Hard-paste porcelain. c1852.

12 Homer Laughlin China Co, East Liverpool, Ohio USA. Late 18thC.

13 W H Goss, Stoke-on-Trent, England. Late 19thC.

14 T Mayer, Stoke-on-Trent, England. c1829.

15 Florence, Italy. Faïence. Late 19thC.

16 Hanks & Fish, Swan Hill Pottery, South Amboy, New Jersey, USA. c1849.

15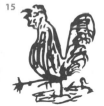

16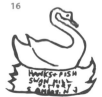

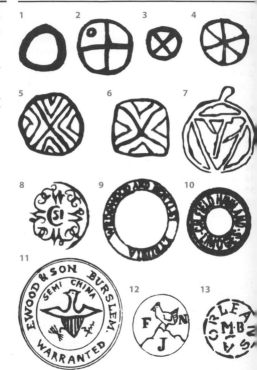

CIRCLES

1–2 Faenza, Italy. Faïence. 16th–17thC.

3 Spode, Stoke-on-Trent, England. Impressed. Late 18thC.

4 Hochst, Germany. Hard-paste porcelain. Painted blue, red, gold. 1750–65.

5–6 Worcester, England. Hard-paste porcelain. Underglaze blue. Late 18thC.

7 Bow, London, England. Soft-paste porcelain. Late 18thC.

8 Ken & Binns, Worcester, England. Porcelain. 1852–62.

9 Wedgwood & Bentley, Etruria, England. 1769–80.

10 Charles Field Haviland Co, Limoges, France. c1882.

11 Enoch Wood & Sons, Burslem, England. c1790.

12 Ilmenau, Germany. Porcelain. 19thC.

13 Orléans, France. Hard-paste porcelain. c1800.

14 Urbino, Italy. Pottery. 16thC.

15 Cologne, Germany. Pottery. 17thC.

16 Minton, Stoke-on-Trent, England. Hard paste porcelain. Printed. 1800.

14 **15** **16**

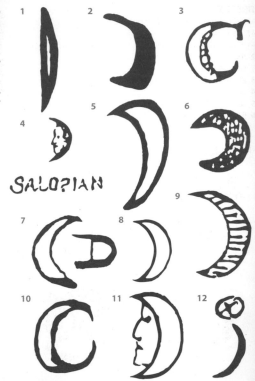

SALOPIAN

CRESCENTS

1–2 Bow, London, England. Porcelain. c1750–75.
3–7 Caughley, England. Painted blue. c1775–99.
8–11 Worcester, England. Hard-paste porcelain. c1751–1800.
12 Nymphenburg, Germany. Porcelain. Impressed or incised. Mid- to late 18thC.
13 Pinxton, England. Soft-paste porcelain. 1796–1801.
14 Turkey. Porcelain. c1850.
15 Munden, Germany. Faïence. 18thC.
16 Faenza, Italy. Faïence. 16thC.

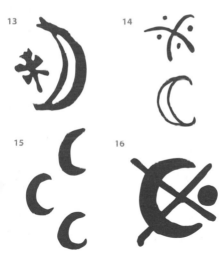

13

14

15

16

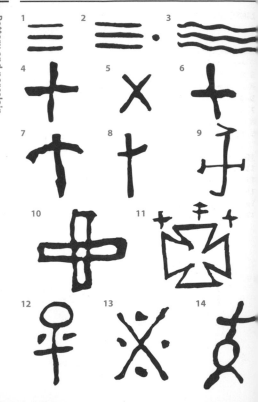

LINES AND CROSSES

1 St Petersburg, Russia. Hard-paste porcelain. Painted blue. Late 18thC.

2 Royal Copenhagen Factory, Copenhagen, Denmark. 1830 45.

3 Royal Copenhagen Factory, Copenhagen, Denmark. c1775.

4 Varages, France Faïence. c1770.

5–6 Bristol, England. Porcelain. Painted colour. c1770.

7 Leeds, England. Painted colour. c1770.

8 Chelsea, London, England. Porcelain. 1745–84.

9 Nymphenburg, Germany. Porcelain. Impressed or incised. Late 18thC.

10 Bow, London, England. Mid-18thC.

11 Copenhagen, Denmark. c1770.

12–14 Bow, London, England. Mid-18thC.

15 Meissen, Germany. 19thC.

16 Longton Hall, Staffordshire, England. 1749–60.

17 Caughley, England. 1775–99.

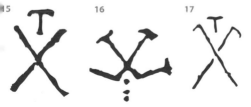

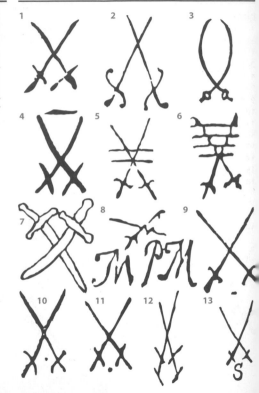

CROSSED SWORDS

1–8 Marks from the Meissen factory in Germany, all painted blue.

1 Early 18thC.

2–3 c1730.

4–6 Mid-18thC.

7–8 c1723.

9 Worcester, England. Mid-18thC.

10 Bristol, England. Porcelain. Painted blue, gold. Mid-18thC.

11 Derby, England. Mid-18thC.

12 Coalport, Coalbrookdale, England. Early 19thC.

13 Samson, Edme, Paris, France. Late 19thC.

14 Caughley, England. Painted blue. 1775–99.

15 Jacob Petit, Fontainebleau, France. 1830–40.

16–17 Bristol, England. Porcelain. Painted blue or gold. 1773–81.

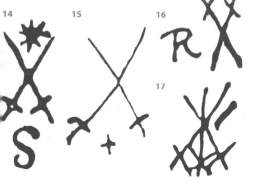

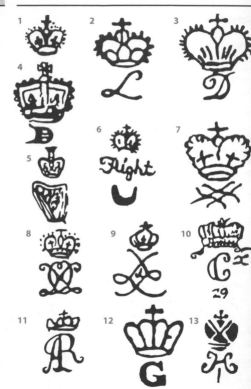

CROWNS

1 Derby, England. 1775–70.
2 Bloor, Derby, England. 1811–48.
3 Vincennes, France. Hard-paste porcelain. c1765.
4 Derby, England. Painted red or violet. c1780–4.
5 Belleek, Ireland. Late 19thC.
6 Worcester, England. c1813–40.
7 Derby, England. c1784–1815.
8 Royal Crown Derby, Derby, England. 1877–9.
9 Sèvres, France. 1773.
10 Sèvres, France. 1824–30.
11 Meissen, Germany. 1720–50.
12 Leeds, England. Earthenware. Mid-18thC.
13–14 St Petersburg, Russia. Porcelain. Painted colour.
Late 18thC.
15 Herculaneum, Liverpool, England. Impressed or printed.
1800–41.
16 James Clews (potter), Cobridge, England. Earthenware.
Blue printed. c1819–29.

14

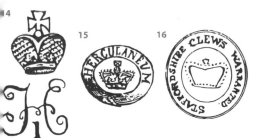

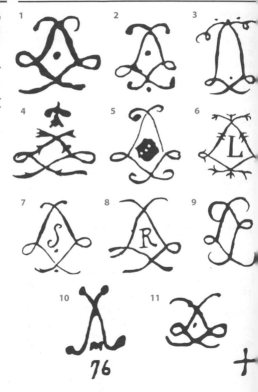

CURVES

1–5 Sèvres, France. Soft-paste porcelain. 1745–53.

6–8 Sèvres, France. Soft- and hard-paste porcelain. 1764–71.

9 Worcester, England. Mid-18thC.

10 Minton, Stoke-on-Trent, England. 1800–1831.

11 Coalport, Coalbrookdale. Porcelain. Early 19thC.

12–13 Buen Retiro, Madrid, Spain. 1759–1808.

14 Niderviller, France. Late 18thC.

15 Nuremburg, Germany. Early 18thC.

16 Nymphenburg, Germany. c1747.

1 2 3

4 5 6

O. F. L

7 8 9

10 11

FLEURS-DE-LYS

1 St Cloud, France. Soft-paste porcelain. Impressed. c1680–1766.

2 Rouen, France. Faïence. Painted colour. 16thC.

3 Bow, London, England. Soft-paste porcelain. Painted blue. c1730.

4–5 Marseilles, France. Faïence. Late 18thC.

6–8 Buen Retiro, Madrid, Spain. Soft-paste porcelain. 1759–1808.

9–10 Ginori, Italy. Painted blue. 1820–50.

11 Minton, Stoke-on-Trent, England. Painted green. After 1850.

12 Capo-di-Monte, Naples, Italy. 1730–40.

13 Orléans, France. 1753–1812.

14–15 Lowesby, England. Mid-19thC.

FLOWERS AND TREES

1–4 'De Roos' (The Rose), Delft, Holland. Late 17thC.

5 Longport, Staffordshire, England. c1825.

6 Rose & Co, Caughley, England. Hard-paste porcelain. Painted colour. 1799.

7 Coalport, Coalbrookdale, England. Early 19thC.

8 Volkstedt factory, Thuringia, Germany. Porcelain. Late 18thC.

9 Greuby Faïence Co, Boston, Mass., USA, c1900.

10 Imenau, Germany. Faïence. porcelain. Late 18thC.

11 Limbach, Thuringia, Germany. Porcelain. Late 18thC.

12–13 Grosbreitenbach, Germany. Hard-paste porcelain. Painted colour.

14 Berlin, Germany. Hard-paste porcelain. Painted blue, green or gold. c1800. Often on damaged pieces.

15 Delft, Holland. Faïence. 18thC.

16 'De Ster' (The Star), Delft, Holland. Faïence. c1720.

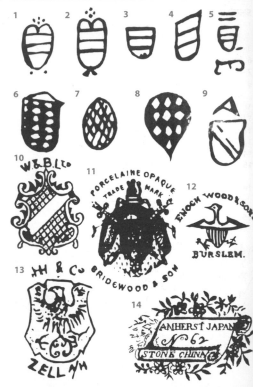

1 2 3 4 5

6 7 8 9

10 W.&B.L.TD

11 PORCELAINE OPAQUE
TRADE MARK

12 ENOCH WOOD & SON
BURSLEM.

13 H & Co BRIDEWOOD & SON

ZELL w/m

14 AMHERST JAPAN
No 62
STONE CHINA

SHIELDS

1–2 Royal Factory, Vienna, Austria. Hard-paste porcelain. Painted blue. 1750–80.

3–5 Royal Factory, Vienna, Austria. Incised, 1744–1820

6 Nymphenburg, Germany. Porcelain. 1754–1862.

7–8 Nymphenburg, Germany. c1800.

9 Ansbach, Germany. Hard-paste porcelain. Painted blue. Mid- to late 18thC.

10 Wood & Barker, Burslem, England. 19thC.

11 Bridgwood & Son, Longton, England. 19thC.

12 Enoch Wood & Sons, Burslem, England 1818–46.

13 Zell, Germany. Glazed earthenware. After 1818.

14 Stoke-on-Trent, England. Porcelain. c1799.

15 Copeland & Garrett, Spode, Stoke-on-Trent, England. 1833–47.

16 Minton, Stoke-on-Trent, England. After 1868.

SQUARES

1–4 Meissen, Germany. Bottger red stoneware. c1710–20.

5 John & David Elers (potters), Newcastle, England. Stoneware. c1690–1710.

6 Chelsea, London, England. Porcelain. 1745–85.

7–11 Worcester, England. Porcelain. Late 18thC.

12 Derby, England. Painted blue. c1775.

13–14 Bow, London, England. Mid-18thC.

15 Mayer & Newbold, Longton, Staffordshire, England. Painted red. 19thC.

16 Baden, Germany. Mid-18thC.

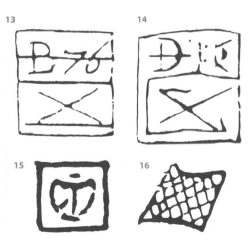

13

14

15

16

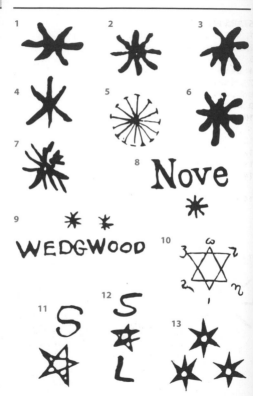

1

2

3

4

5

6

7

8 Nove

9 WEDGWOOD

10

11 S

12 S L

13

STARS AND SUNS

1 Isaac Farnsworth, Derby, England. 18th–19thC.

2, 5, 6 Ginori, Doccia, Italy. 1735–7.

3 Wallendorf, Thuringia, Germany. Porcelain. c1764.

4 'De Ster' (The Star), Delft, Holland. Faïence. c1690.

7 Caughley, England. Porcelain. c1750.

8 Nove, Italy. Faïence, porcelain. Painted gold. Mid-18thC.

9 Wedgwood, Etruria, England. Impressed. 1765–1850.

10 Nymphenburg, Germany. Hard-paste porcelain. Late 18thC.

11 Savona, Italy. 18thC.

12 Seville, Spain. 19thC.

13 Nevers, France. Faïence. 17thC.

14–15 St Cloud, France. Soft-paste porcelain. Painted blue. 1678–1766.

16 Robert Bloor, Derby, England. c1811–48.

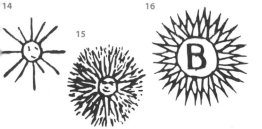

14 15 16

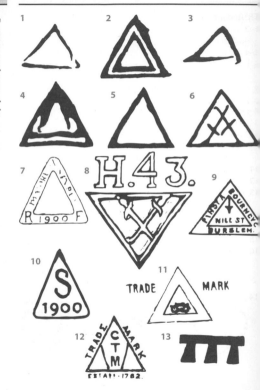

1

2

3

4

5

6

7

MYHN
R 1900 F

8

H.43.

9

FINEST BOURNEY
MILL ST
BURSLEM

10

S
1900

11

TRADE MARK

12

TRADE MARK
C
T
M
ESTAB. 1782.

13

TRIANGLES AND HEARTS

1-2 Chelsea, London, England. Soft-paste porcelain. Painted gold or red. c1745–50.

3-4 Bow, London, England. Incised. Painted blue. Mid-18thC.

5 Derby, England. Hard-paste porcelain. Impressed. Painted blue. Mid-18thC.

6 Bristol, England. Hard paste porcelain. Impressed. c1763–73.

7 Sèvres, France. 1900–2. Mark tells year of decoration.

8 Meissen, Germany. Porcelain. Impressed. c1766–80.

9 Burslem, England. 19thC.

10 Sèvres, France. Hard-paste porcelain. Painted black. Soft-paste painted blue. c1900–11.

11 Hanley, England. 19thC.

12 Newcastle, England. 19thC.

13 Orléans, France. Hard- and soft-paste porcelain. Painted colour. c1753–1812.

14 Rue Popincourt factory, Paris, France. Porcelain. c1782–1835.

15 Richard Chaffers, Liverpool, England. c1740–65.

16 Bruges, Belgium. 18thC.

14	15	16

ORIENTAL COPIES

1–6 Worcester marks, 1751–83.
7 Caughley, England. c1772–99.
8 Burslem, England. Late 17th or early 18thC.
9–11 Meissen, Germany. Böttger ware. Early 18thC.
12 Samson 'the Imitator', Paris, France. Found on imitation Lowestoft (England). c1875.
13 Coalport, Coalbrookdale, England. Hard-paste porcelain. c1828–50.
14 Delft, Holland. Faïence. Painted blue. c1800.
15 'De Romeyn' (The Roman), Delft, Holland. Faïence. c1671.

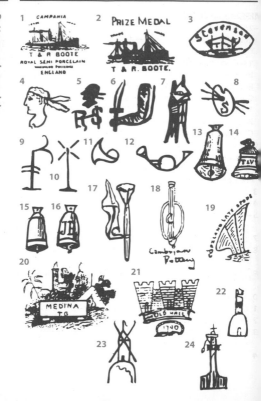

MISCELLANEOUS

–2 T & R Boote, Burslem, England. Late 19thC.

Cobridge, Staffordshire, England. Painted blue. c1800.

Delft, Holland. Faïence. 18thC.

'De Oude Moriaan's Hooft' (The Old Moor's Head), Delft, Holland. Faïence. c1680.

Royal Vienna Factory, Austria. c1850.

Derby, England. Hard-paste porcelain. Painted blue. 1745–1848.

Paris. Hard-paste porcelain. Painted gold. c1870.

Caughley, England. Porcelain. 1750–1814.

0 Clignancourt, France. Hard-paste porcelain. c1771–5.

1 Worcester, England. c1751–83.

2 Chantilly, France. Soft-paste porcelain. Painted blue or red. c1725–1800.

3 J & M P Bell & Co, Scotland. Late 19thC.

4 Limoges, France. Hard-paste porcelain. c1736–96.

5–16 Bellevue Pottery Co, Hull, England. Farthenware. c1825.

7 Savona, Italy. 17thC.

8 Cambrian factory, Swansea, Wales. Soft-paste porcelain. c1765.

9 W T Copeland & Sons, Spode, Stoke-on-Trent, England. Porcelain. c1847.

0 Burslem, England. c1795.

1 Old Hall Pottery, England. Earthenware. 19thC.

2 Tournay, Belgium. Soft-paste porcelain, late 18thC.

3 Clignancourt, France. Hard-paste. Painted blue, gold. c1771–98.

4 Savona, Italy. 18thC.

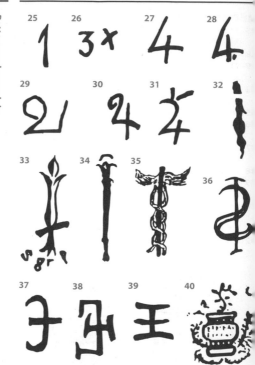

MISCELLANEOUS (continued)

25–27 Bristol, England. Pottery, porcelain. Painted blue or gold. 18thC.

28 Nevers, France. Pottery. Painted colour. 16thC.

29–31 Plymouth, England. Hard-paste porcelain. Painted red, blue or gold. c1768.

32–34 Royal Factory, Berlin, Germany. Hard-paste porcelain. Painted blue. c1760.

35 Hanley, England. 19thC.

36 Nymphenburg, Germany. Porcelain. Impressed or incised. Late 18thC.

37 Caughley, England. Hard-paste porcelain. Painted blue. c1750.

38 Bow, London, England. Porcelain. c1750.

39 Bristol, England. Hard-paste porcelain. Painted colour. c1770.

40 Bristol, England. Hard-paste porcelain. Printed blue. c1800.

41 Job Ridgways (potter), Shelton, England. c1794.

42 Podmore, Walker & Co, Staffordshire, England. c1755.

41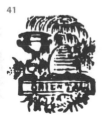

42